CDQ
CHARACTER DESIGN QUARTERLY

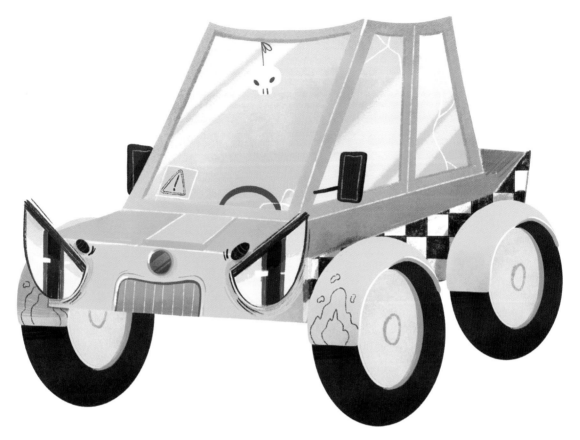

Image © Archina Laezza

CONTENTS

WELCOME TO *CHARACTER DESIGN QUARTERLY 21*

One of the best things about working on *CDQ* is the endless imagination that our wonderful artists bring to each issue. *CDQ 21* is packed with all sorts of fascinating characters that pull from every aspect of life and beyond — from witches to cars, astronauts to gardeners, inspiration can come from literally anywhere!

Leading the way with a fantastically creative critter design is this issue's cover artist, the incredibly talented Amelia Bothe, who shares the process behind her wildly original creatures. Looking for something a bit more down to earth? Wouter Bruneel shows us how to create stylized versions of three everyday characters. Or maybe you'd rather just head completely out of this world? Raúl Treviño creates a unique cosmic encounter of bizarre proportions.

As always, we had the pleasure of interviewing some leading artists — be sure to check out our fascinating chats with veteran animator Carlos Luzzi and *CDQ* favorite Meike Schneider, who both share a whole lot of interesting and useful facts, and, of course, loads of their brilliant art.

That's enough from me, I'll let you discover the rest of this fantastic issue for yourself — turn the page and meet an incredible cast of characters, and then be inspired to go and create some wonderful designs of your own.

SAM DRAPER
EDITOR

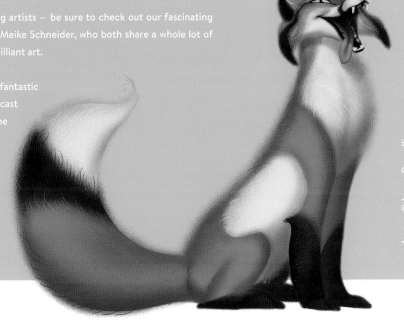

Image © Laura Pauselli

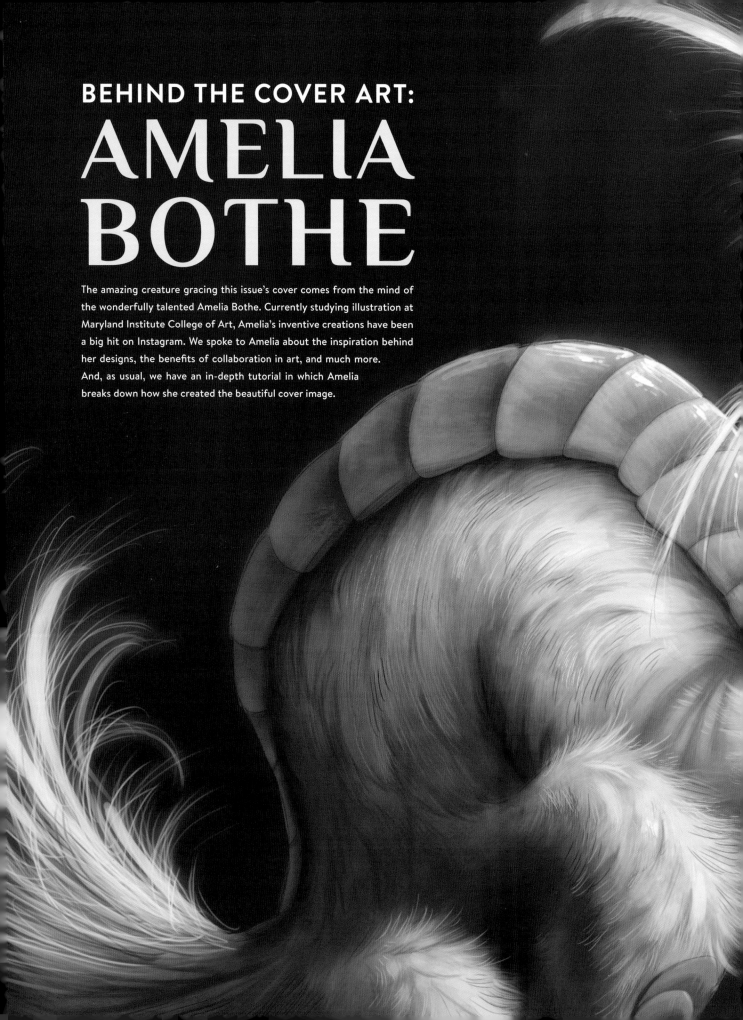

BEHIND THE COVER ART:
AMELIA BOTHE

The amazing creature gracing this issue's cover comes from the mind of the wonderfully talented Amelia Bothe. Currently studying illustration at Maryland Institute College of Art, Amelia's inventive creations have been a big hit on Instagram. We spoke to Amelia about the inspiration behind her designs, the benefits of collaboration in art, and much more. And, as usual, we have an in-depth tutorial in which Amelia breaks down how she created the beautiful cover image.

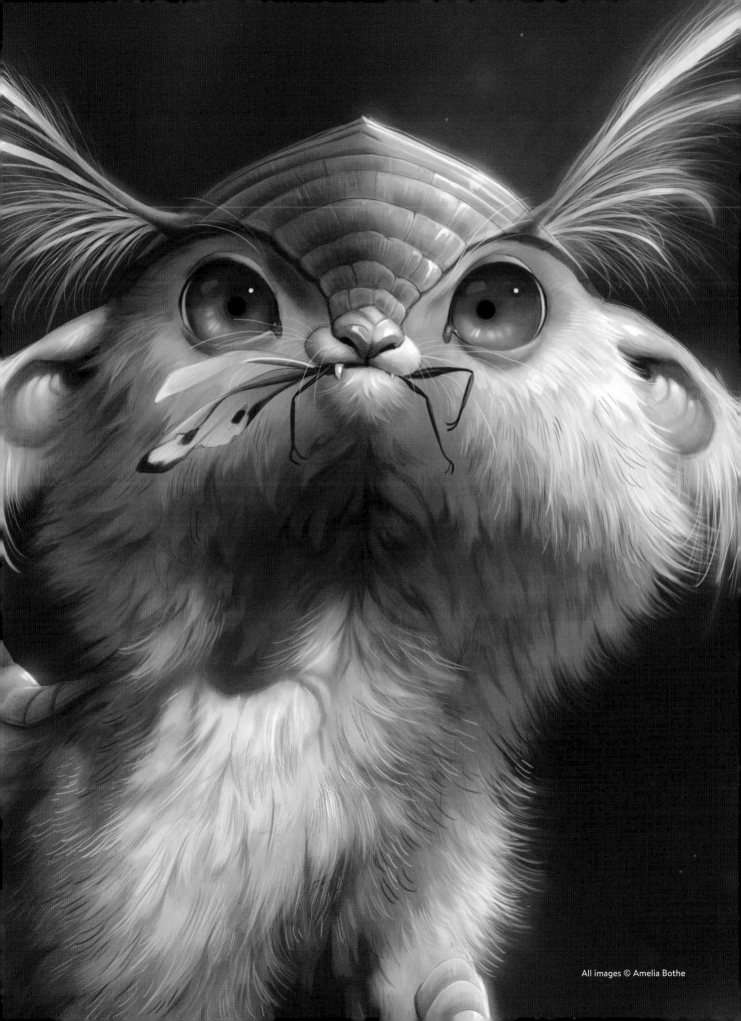

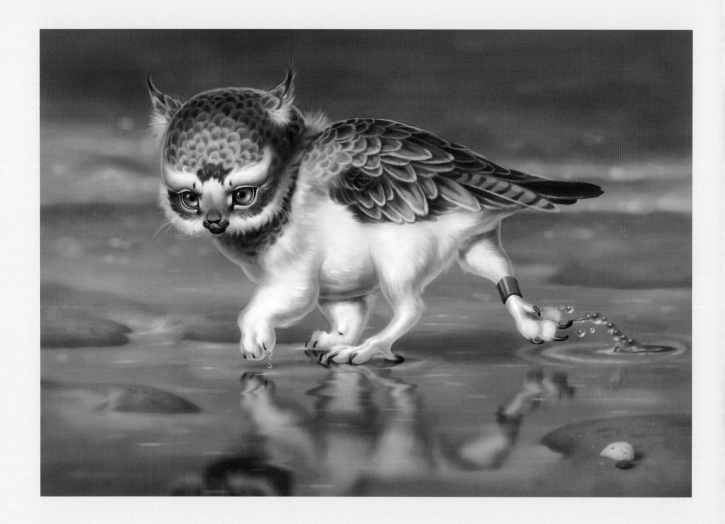

Hi Amelia, we were so excited to have you work on the cover this issue! Can you tell us a little about your journey into character design?

I feel so honored to have this opportunity! I've always loved character design, specifically animal and creature designs. As a kid, I would create fan characters inspired by things like *Pokémon* and *How To Train Your Dragon*, and then, gradually, I started creating my own original creatures. Today, I still love indulging in making fan creations inspired by nostalgic properties, but I mostly focus on coming up with my own critters! I think I'll always prefer animal design, as opposed to human design, because of the sheer variety the animal kingdom has to offer in terms of inspiration.

Animals and nature are obviously a big part of your work – especially creating fantastical creatures drawn from several animals. Where do you get the inspiration for these creations?

Some of my favorite artists, such as Aaron Blaise and Devin Elle Kurtz, would create these sorts of fantastical creatures, so I was initially very inspired by them to try my hand at it! Inspiration for my creature mash-ups usually sparks from taking a trip to the zoo or discovering a species I've never seen before on the internet. I get very excited when I find two or three animals that I just know will "fit" nicely together and form an interesting new critter. My favorite aspect of design to focus on is mixing and matching textures, such as feathers, fur, and scales.

This page:
Piping Pliffon — A piping plover-inspired griffon

Opposite page:
Little Sea Dragon — A small aquatic dragon

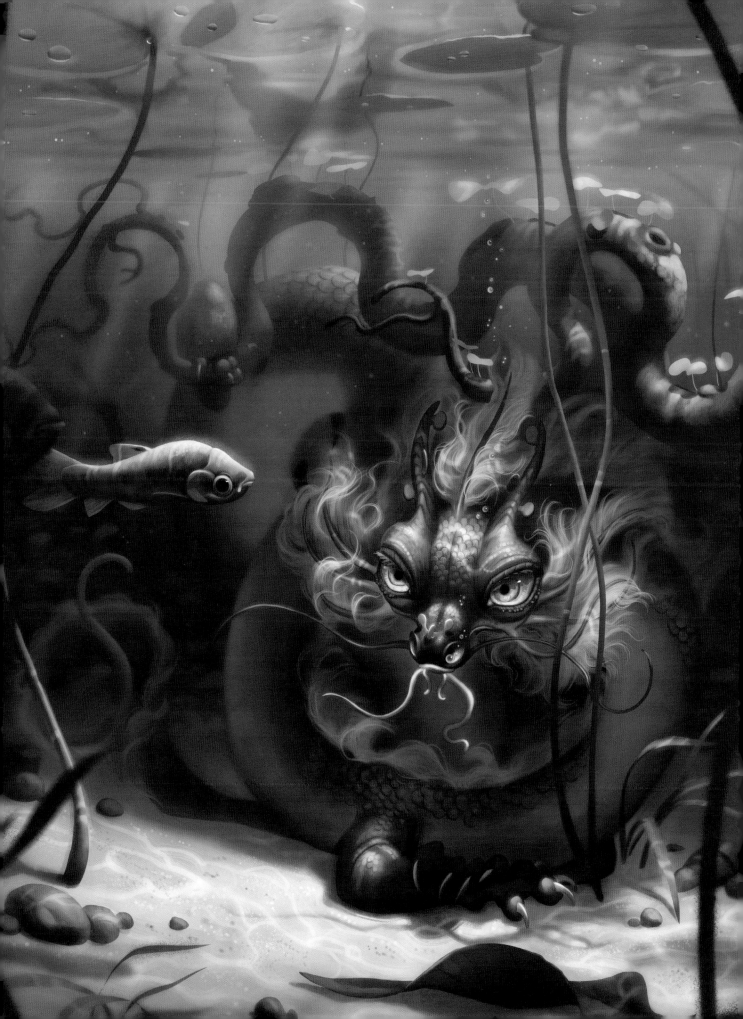

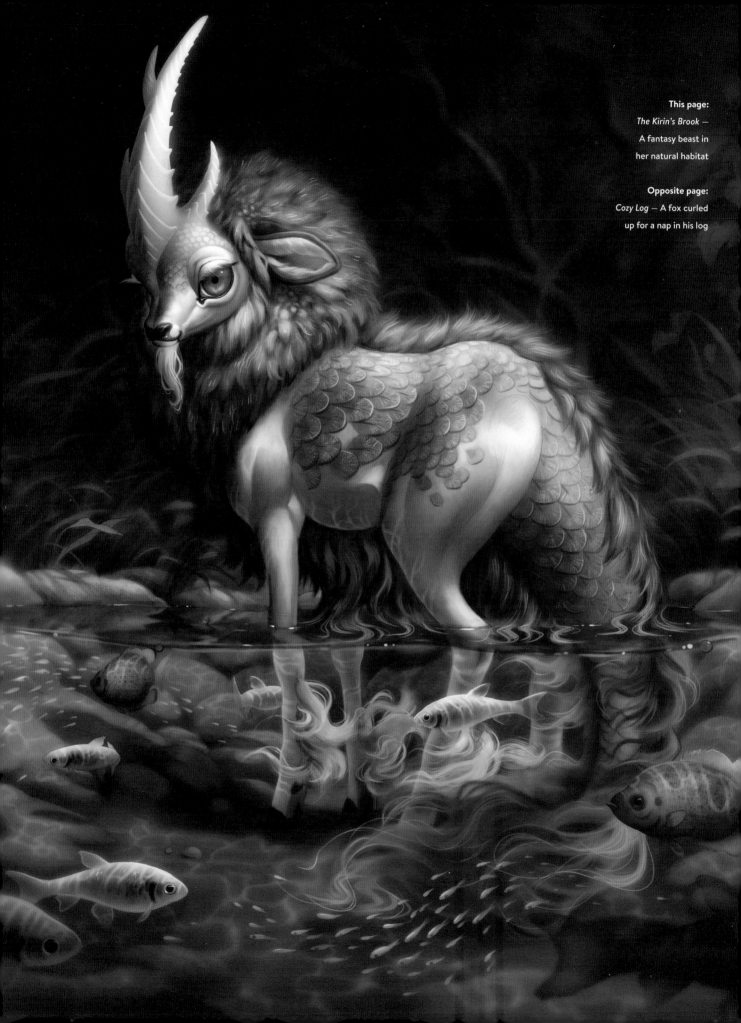

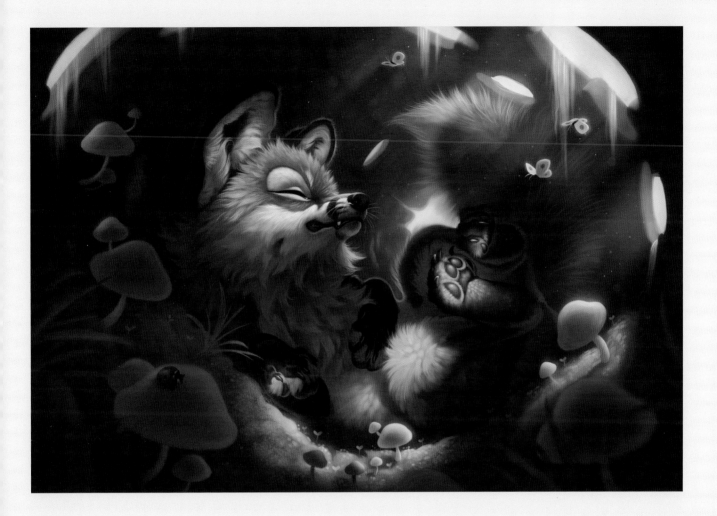

You also regularly take part in multiple animator projects (MAPS) on YouTube — is collaboration an important part of your work?

Yes, especially for MAP parts where I work with a "director" that has a clear vision for the animation, and awesome character designs and storyboards which I get to work with. Occasionally, I also do painting collaborations, whether by working with another artist to create a small series of pictures, or actually passing a digital file back and forth until the image is finished. I'm very excited to work on much bigger projects eventually, alongside a large group of artists all working toward the same goal.

When rendering your characters, how much are you thinking about lighting and how it will be represented in your painting?

Lighting is always one of the first things I consider when brainstorming a piece. It's also one of the most exciting parts of a painting for me, because of the technical challenge of using lighting to my advantage to convey 3D forms accurately. Recently, I've also enjoyed playing with the emotional weight that different lighting setups can provide for a piece. One of my favorite things about working in Photoshop is the different way to adjust lighting with layer modes — it makes the whole process of painting light a lot more intuitive.

Your art manages to convey such realistic depth and design, despite the often fantastical subject matter. Do you have any tips for achieving this look?

Lighting is my favorite way to convey depth and form. I like to push the subject into the foreground light and the background into the shadow, and also use shadow for the extreme foreground, as well. I try to achieve realism, or semi-realism, with my textures, lighting, and rendering, playing with fantastical anatomy, colors, and overall stylization of the critter. The final outcome is hopefully "believable" rather than strictly "realistic" — grounded in reality while also fantastical. It's a difficult balance and I'm still working to find that elusive perfect middle ground!

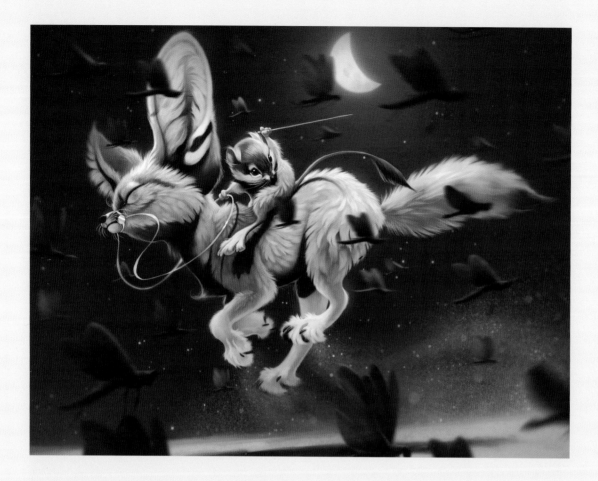

Do you find it harder to stick to a "traditional" creature design or to create one of your animal mashups? What are the different challenges with each style?

For me, both are an equally fun challenge in different ways. I think creativity is important at different times during the process. For "traditional" creature designs, like creating a simple anthropomorphic animal, the challenge lies in making the design stick out purely through style, characterization, and maybe clothing design. With the animal mash-ups, there's a lot more to figure out, in terms of the anatomy, colors, and textures — and there's no expectation for what the final critter will look like! I really enjoy both scenarios, but as far as difficulty is concerned, I find classic animal designs to be a bit harder because of the risk of falling into cliché.

With your Instagram and YouTube always packed with new content, you seem to be incredibly prolific! How do you find the time to create so much work?

I'm honestly just incredibly lucky and privileged to have so much time to work on my art. I've been able to make freelancing my part-time job and drawing is essentially my only hobby so, especially during the pandemic, I've just naturally had lots of time to create! Now that I'm on campus at college it's a bit different — my schoolwork still mostly consists of creating artwork, so I just try to section out parts of my day to work on personal art, too. I've always actively sought out that precious time where I can just sit and work uninterrupted for hours!

Finally, are there any upcoming projects we should be looking out for?

My biggest focus right now is getting through college, so currently my plans are very short-term for little personal pieces I'd like to do between my schoolwork. Once summer rolls around I'd absolutely love to pursue writing and illustrating a small poetry book! Next year might also be the year I finally try my hand at animating an original short film, which has been a dream of mine for a very long time.

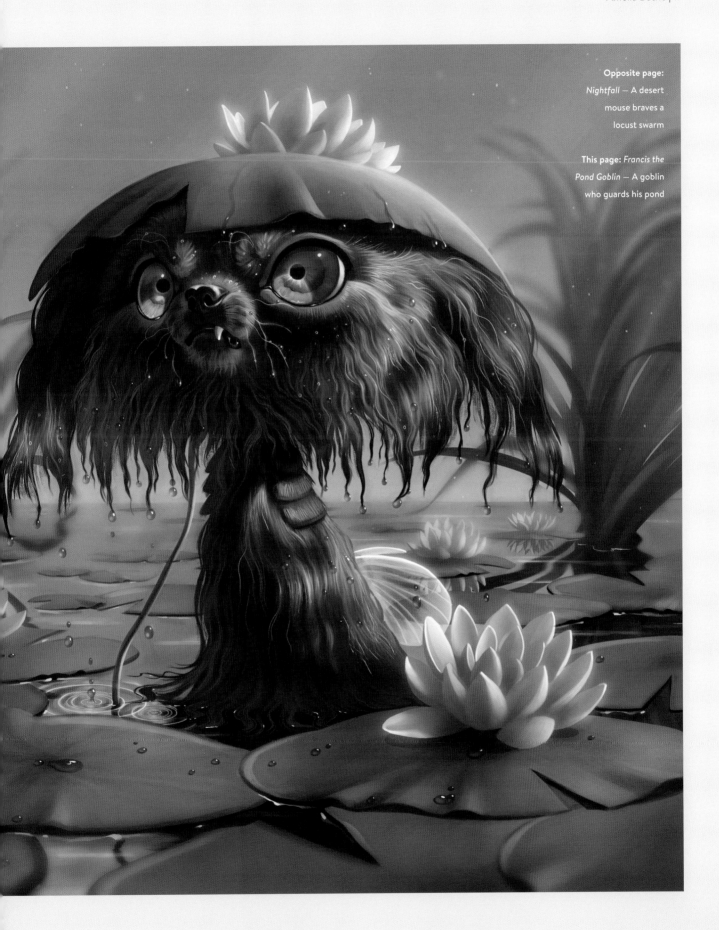

CRAFTING THE CRITTER

INITIAL SKETCHES

Your initial sketches are a chance to be loose and experimental, as you figure out what traits you want your creature to possess. Try to carve out big shapes first and work your way to the smaller details, keeping in mind the creature's silhouette. Iterate on your sketches by lowering the opacity of the previous layer and sketching a new version on top until you're happy with the design. At this stage you can also solidify the composition of your picture — in this case, the composition is purely functional to fully frame the creature and its butterfly breakfast.

THE TIED-DOWN SKETCH

The tied-down sketch will function as your guide for the entirety of the painting process. Lay down thin, clear lines over your initial sketch, picking out which strokes will form the final solid drawing of your creature. Don't worry if your lines aren't perfect, as the tied-down sketch will not be visible in the final illustration — it's a guide for color placement, anatomy forms, and fur direction, and it will be erased or otherwise covered up by the painting process later on.

BASE COLORS

Next, we create a layer with the neutral base colors that you will build from as you paint. Think of these colors as the "local colors" of the creature, or what the creature looks like when not affected by any light or shadow. Add some subtle color variation all over the creature for added realism. At this stage, you should also lay in a base color for the background to make sure the colors of the creature will play well off the environment. In this case, a dark green background will nicely complement the lighter pinks and yellows of the creature.

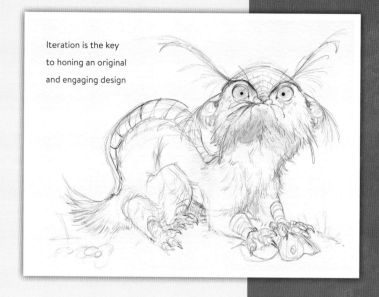

Iteration is the key to honing an original and engaging design

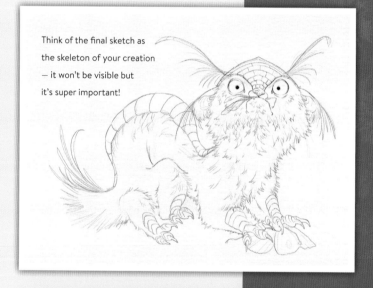

Think of the final sketch as the skeleton of your creation — it won't be visible but it's super important!

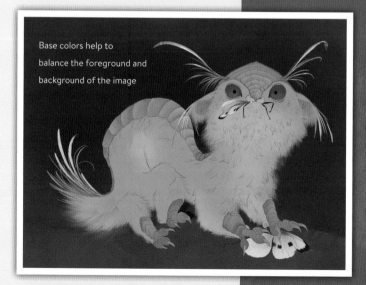

Base colors help to balance the foreground and background of the image

"EXPERIMENT WITH VARIOUS LAYER MODES, SUCH AS HARD LIGHT, SOFT LIGHT, AND MULTIPLY IN ORDER TO EFFICIENTLY PAINT LIGHT AND SHADOW"

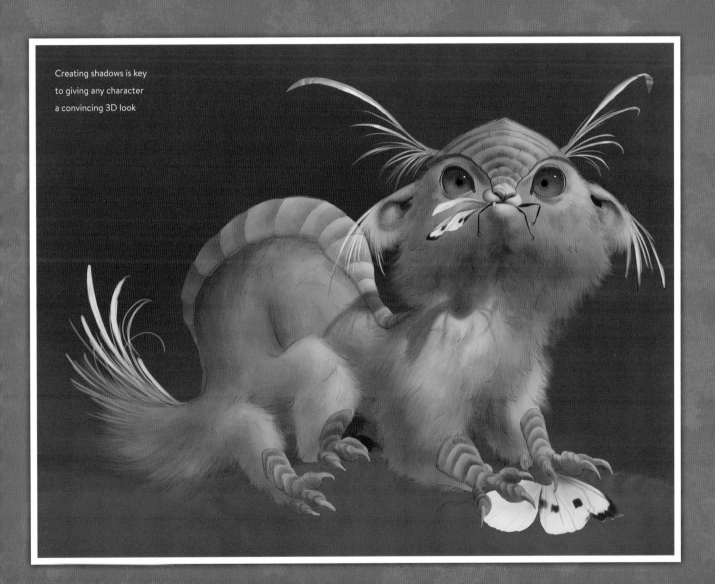

Creating shadows is key to giving any character a convincing 3D look

LIGHT AND SHADOW

Begin painting in the light and shadow on your creature, keeping in mind your chosen light source. Experiment with various layer modes, such as Hard Light, Soft Light, and Multiply in order to efficiently paint light and shadow. About 60% of all the layers I've used for this illustration are one of these three modes. Use Clipping Masks to ensure whatever you paint during this step does not exit the bounds of your base colors below. Don't worry too much about textures yet — at this point, we are primarily trying to define the 3D form of the creature, as well as lay in cast shadows.

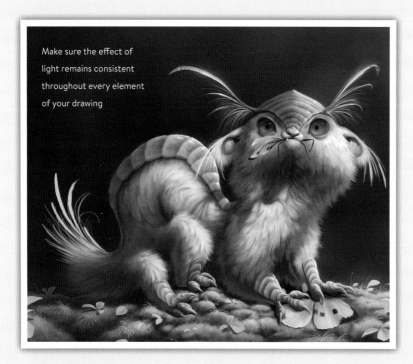

Make sure the effect of light remains consistent throughout every element of your drawing

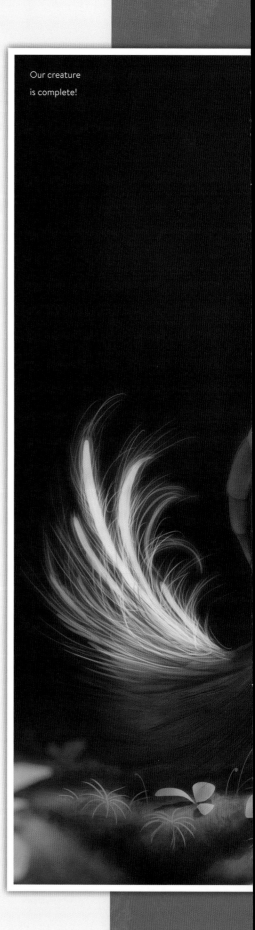

Our creature is complete!

RENDERING

It's time to have fun rendering the creature and its environment! Use a mixture of normal, opaque layers, and other layer modes to slowly build up texture and form. Play around with different brushes that might allow for easier or more interesting rendering, but remember that default brushes can often get the job done just as well. Add greenish bounce light into the shadow areas of the creature in order to place it into the context of its environment, and make sure all elements of the scene are affected consistently by the same light source.

FINAL TWEAKS

Go back over the entire image with a couple more Multiply and Hard Light layers to really push back the shadows and pull forward the highlights. Add a lens blur effect to the furthest background elements if you'd like to give the piece a photographic feel.

Make any final tone adjustments by making sure the highest contrast area of the illustration is the focal point. To check this, make the image black and white by adding a grey layer set to Saturation mode. Wrap up the image with any final additions of fur strands (don't forget the whiskers!), specular highlights, and color adjustments.

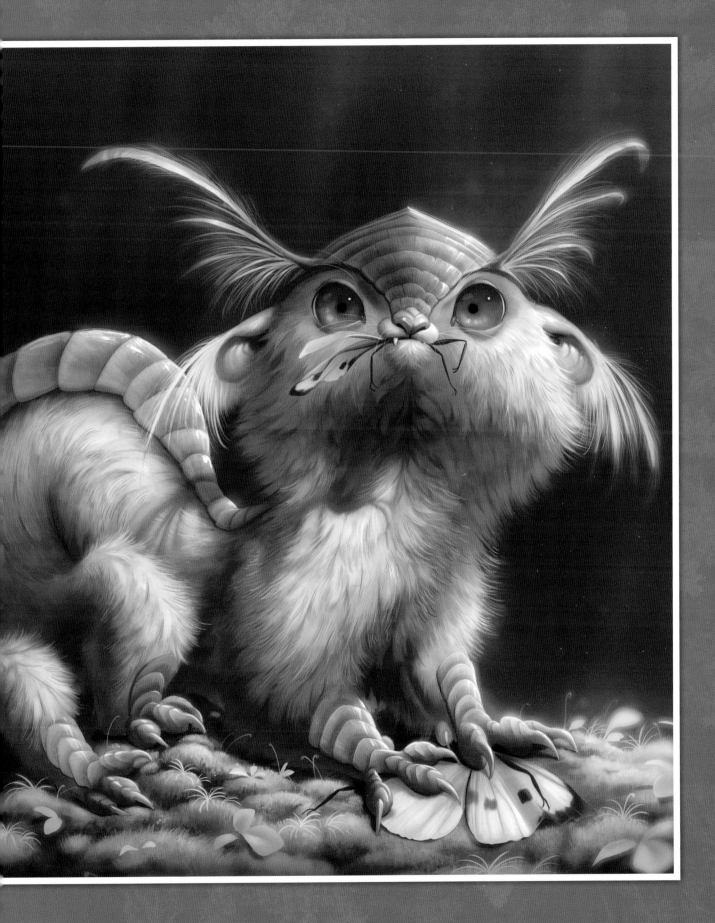

AN APPRENTICE WITCH'S FIRST DAY
JULIA KÖRNER

When I was given the opportunity to create a tutorial for *CDQ*, the prompt sounded magical and interesting, with a lot of scope to create a fun, story-driven, design. Let me walk you through my process of ideation, sketching, and color choices, all the way from the first spark of an idea to a fully digital character illustration.

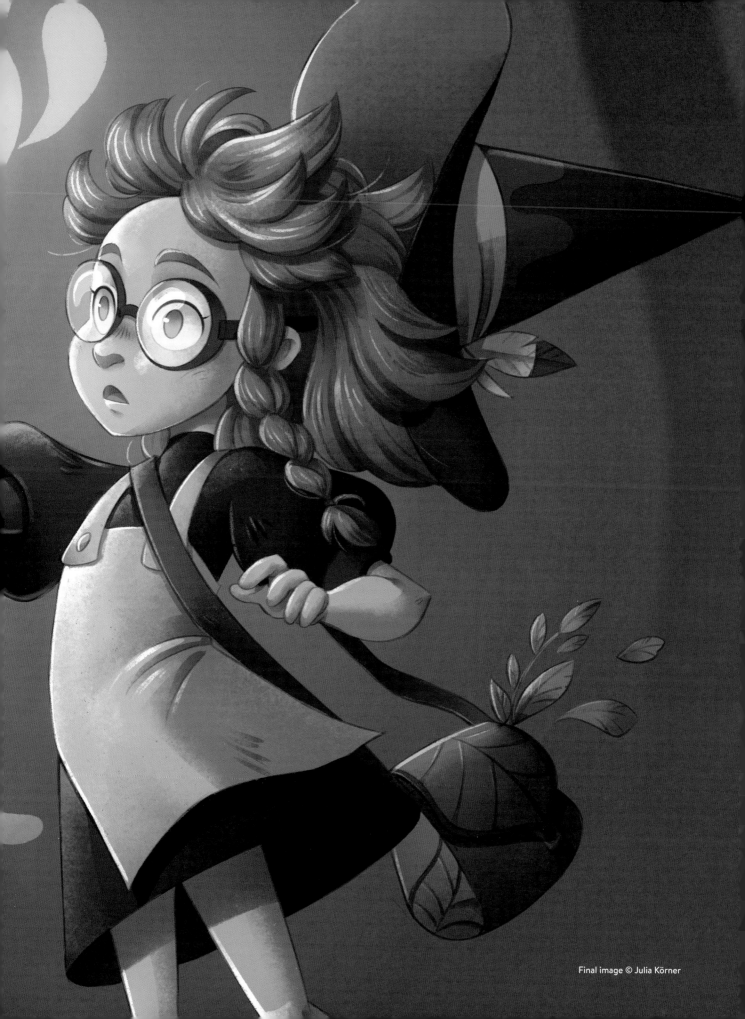

Final image © Julia Körner

A WEB OF IDEAS

The first part of designing a character mostly happens inside your head. As thinking and drawing ideas from your imagination is not a visible part of the process, it's easy to forget just how important it is. Normally, I sit back and let ideas and words I associate with the brief run through my mind, or collect inspirations on a mood board. Here, I draw a mind-map to show how I typically break down my thoughts. I approach each section of the brief separately, collecting my thoughts around three sub-topics: "witch," "first day," and "apprentice." Don't spend too much time on this step — collect the first thoughts that come to mind and you'll find you quickly have a variety of possibilities for your design.

WHICH WITCH IS RIGHT?

With a mind-map of buzzwords complete I like to start collecting more specific in-depth thoughts about my character. Some people like to create a whole background story before starting the design — I personally like to ask myself questions early on that I will then answer with my sketches and approach to design. I think about the time my character is living in, where they are, and what characteristics define them. Alongside my questions, I write out a list of scenes or activities I associate with the little witch I'm going to create.

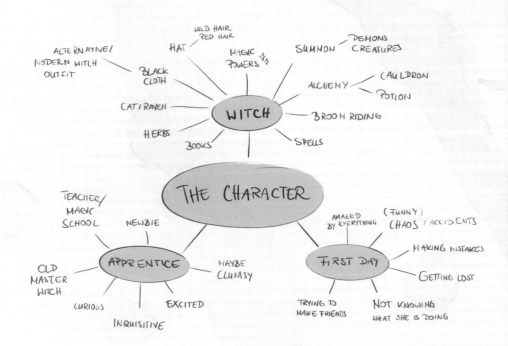

Questions:

- more fantasy world? more realistic world?
- classical witch setup? (black cloth, witch hat...)
- alternative/modern witch cloth?
- first day of learning? first day of being a witch
- possible problems/disasters?
- pet companion? if yes which one?
- from a magic family?
- How old?

Feelings:

- excited, new adventure happy, surprised

Scene ideas:

- ☆ Shy witch with artefact/bottle + helper animal
- ★ Alchemist witch with accident explosion
- ☆ Flying problems
- · Happy with books & witch stuff
- ★ Trying to summon sth. (Blobb appears)
- ☆ Collecting fireflies/herbs
- · Making friends with a cat/raven
- ★ Running stressed with books + scrolls
- ★ failed transformation spell

> ## "TO KEEP IT LOOSE I OFTEN PREFER TO START WITH TRADITIONAL SKETCHES ON PAPER. THIS HELPS ME QUICKLY MOVE FROM ONE IDEA TO THE NEXT"

THE FUN BEGINS

Now the real fun can start — the first sketches of our favorite ideas from before. To keep it loose I often prefer to start with traditional sketches on paper. This helps me quickly move from one idea to the next — with no Undo, Scale, or Warp buttons there's less temptation to fiddle with a design. I even try to avoid using an eraser as much as possible and keep the discovery lines. This exercise is most definitely not about perfection! Try to focus on catching a certain mood, feeling, or dynamic, rather than aiming for the perfect perspective or other "correct" parameters. These are all things we will get to and fix later in the process.

Opposite page (top): A mindmap of words associated with the brief

Opposite page (bottom): The more questions you answer now, the easier the design will be

This page: Sketching is where the fun really begins

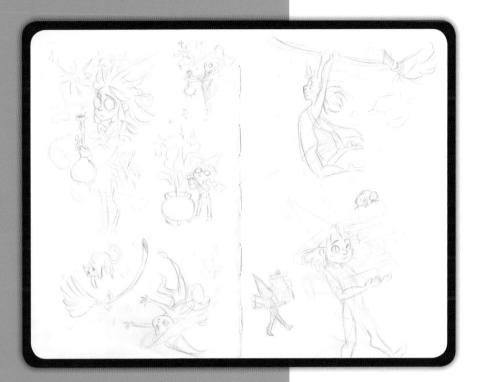

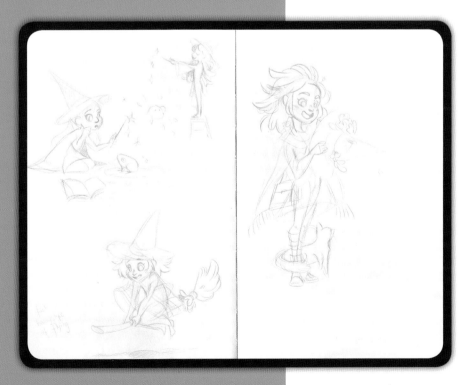

SILHOUETTING SHAPES

After sketching between five and ten designs, the next step is to check the character's silhouette. If you've been drawing on paper, scan or take a photo of your favorite ideas and start to draw their outline on a separate layer. Once the outline is completely defined, fill the shape with a solid color. Looking at characters as silhouettes will help you get a better feeling for which design or pose looks interesting and is easily readable on the page.

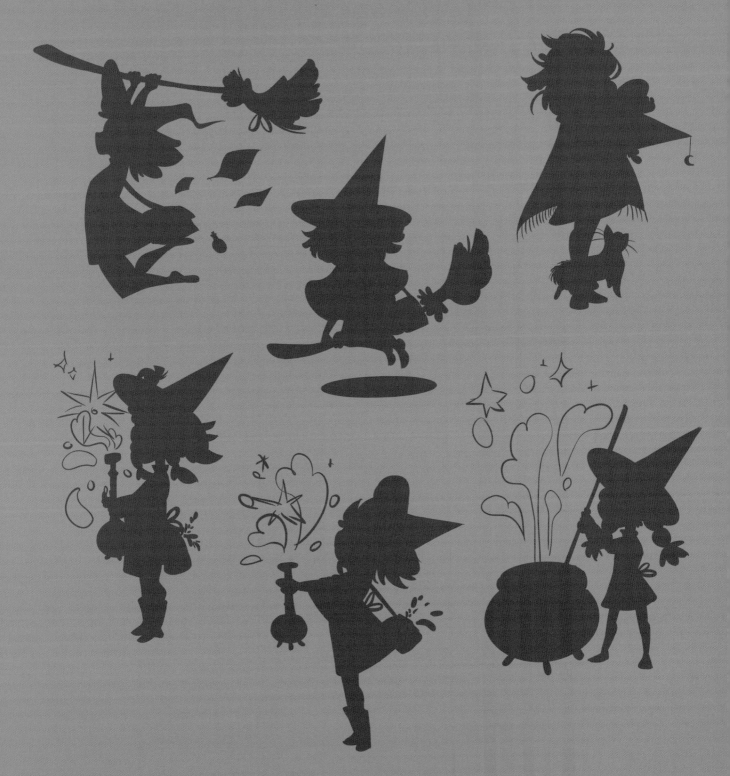

BALANCE AND POSE

The next step is to improve the silhouettes you like. I like to address issues of balance and pose at this early stage, as it's easy to focus on the general shape language and not get distracted by details. I used to struggle with this step, and found that using lines as guides helped.

I now use blue lines to visualize the main shapes of my characters and red lines to visualize the line of action and dynamics. With these tools in place, you can stretch and push the shapes to become more expressive.

Opposite page: Turn your favorite sketches into silhouettes

This page: Play with balance and pose to improve expressiveness

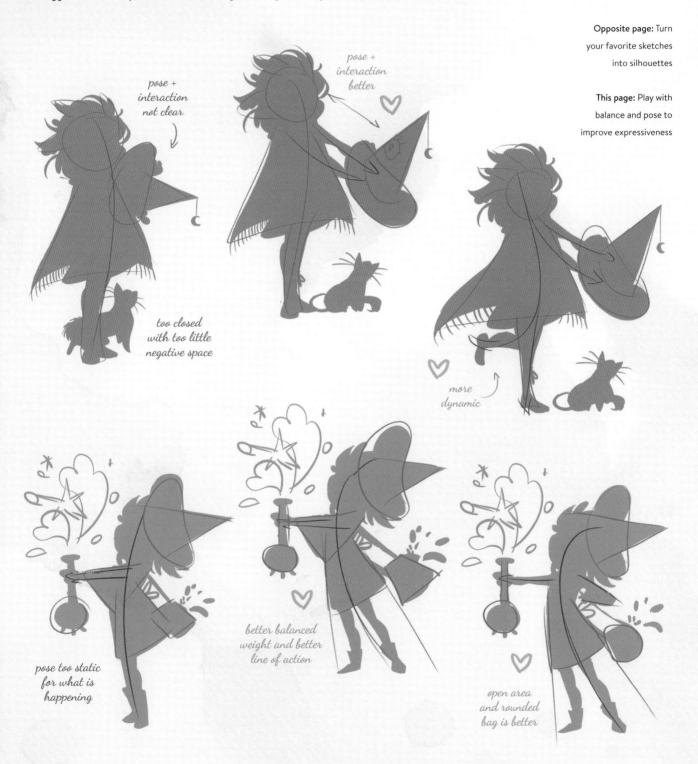

pose + interaction not clear

pose + interaction better

too closed with too little negative space

more dynamic

pose too static for what is happening

better balanced weight and better line of action

open area and rounded bag is better

DECISIONS, DECISIONS

Before we get into too much detail, we need to choose the final design direction. Sketch over your silhouettes and start to add definition, gradually adding more specific elements to the general shapes we've worked with so far. It can be hard to choose which design to go forward with, as you may have two or three favorites. To help decide, go back to your original thoughts on narrative and storytelling and choose the image that best fits the story you're trying to tell. I choose my idea of a witch's apprentice having an alchemical accident — I like the fun and chaos throughout this design!

WHERE AM I?

With a character in place, we now need to consider the rest of the image — what information do we want the background to convey? Creating a simple scene is sometimes optional, but it can do so much to help define your character, their scale, their origin, what they are doing, and what they've done. An effective background can enhance a scene and underline the mood that you want to convey. I create rough thumbnails to explore several different ideas — I'm trying to find the perfect balance between an interesting and simple setting, keeping the focus on the character.

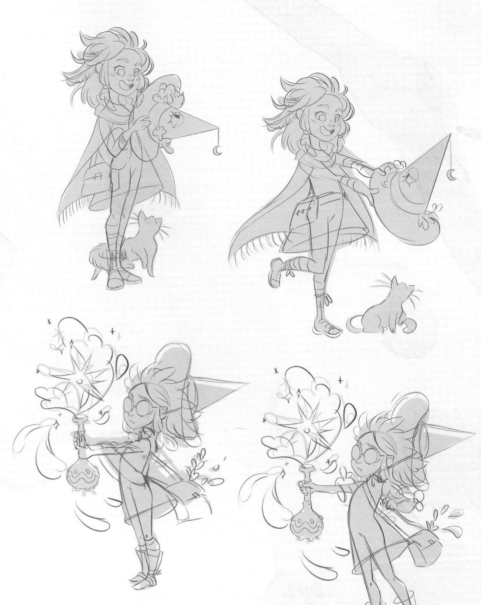

This page (top): Sketching on top of the silhouettes, defining detail, and choosing the design to progress

This page (bottom): Thumbnails of scene variations

Opposite page: Exploring options for facial expressions

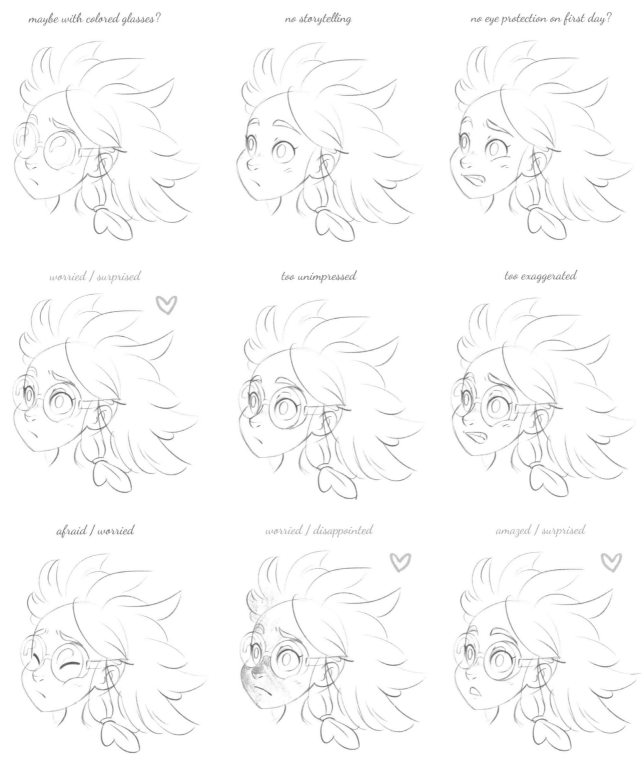

maybe with colored glasses?

no storytelling

no eye protection on first day?

worried / surprised

too unimpressed

too exaggerated

afraid / worried

worried / disappointed

amazed / surprised

BIG MOOD

Who needs words — a single look can say so much! This is an important tool to use for your character design, a character's facial expression can reveal so much about their mindset and mood. Don't be afraid to experiment and try some exaggerated looks, keep trying to find the right look for your character. Once you settle on the mood you're after, find the appropriate tone. For an apprentice witch's first day, I thought amazed and surprised were the emotions that fit best.

"ONE OF MY FAVORITE PARTS OF THE PROCESS IS GIVING LOVE AND ATTENTION TO ALL THE LITTLE DETAILS THAT MAKE UP A GOOD CHARACTER DESIGN"

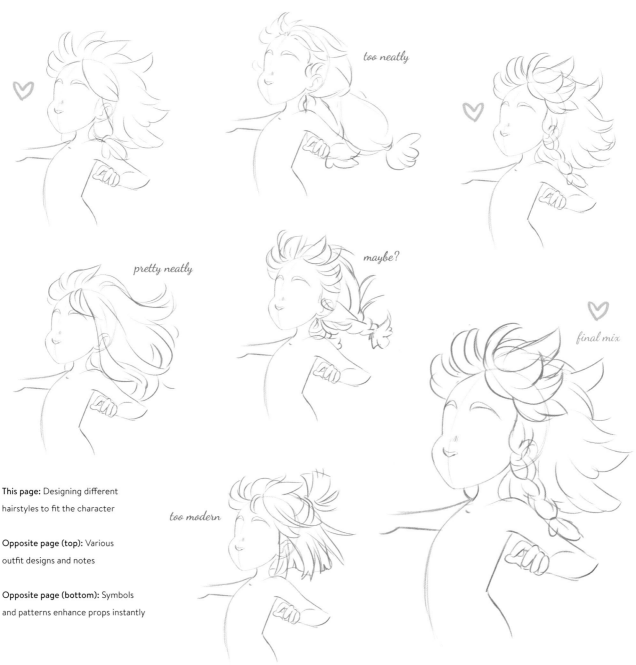

too neatly

pretty neatly

maybe?

final mix

too modern

This page: Designing different hairstyles to fit the character

Opposite page (top): Various outfit designs and notes

Opposite page (bottom): Symbols and patterns enhance props instantly

A GOOD HAIR DAY

One of my favorite parts of the process is giving love and attention to all the little details that make up a good character design. At this point, the rough shapes, dynamics, and pose are all set in stone, so it's time to dive in and think about specific details. As there are endless possibilities for how to design things, keep your notes from the beginning of the process to hand and try not to lose that initial vision! Let's start with the hair — check references for inspiration and try different styles that would suit a witch's apprentice. Iteration is key: keep experimenting and you'll find the perfect look.

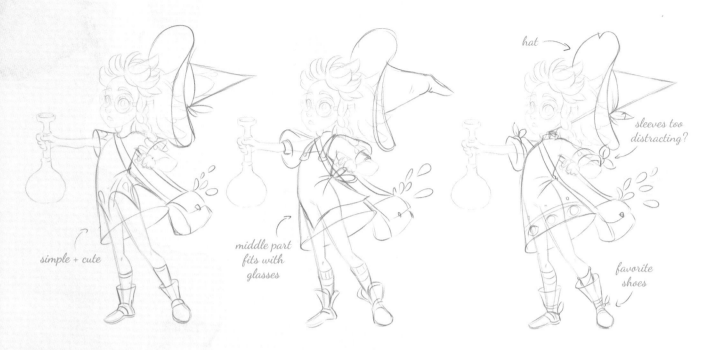

hat

sleeves too distracting?

simple + cute

middle part fits with glasses

favorite shoes

STITCHES FOR WITCHES

Clothing is another great way to tell your character's story without words. Maybe they are practically minded and don't care about their looks? Is fashion important to them, or do their clothes have a specific function or purpose? Asking these questions will help you decide which direction to explore. In this case, I want to create a simple outfit — since it is the apprentice's first day, she wouldn't yet have all the fancy robes and accessories afforded to a proper witch. What she is wearing still needs to fit the task at hand: in this case, learning alchemy, so I choose the design with an apron to show she is doing practical work.

PROP TILL YOU DROP

Props can seem unimportant, and yet they say so much about a character's situation. As with every element, simplicity is important, so choose the few items that help to push the design forward. You can take very ordinary, everyday objects and make them special and personal to your design by adding a few little details. Symbols and patterns are good visual clues that a character belongs to a certain group, so research what is typical and incorporate it into your designs.

ADDING A PERSONAL TOUCH

Even if you're working for a client and you can't decided every aspect of a character's design, you can still add little personal touches. Perhaps use an object that is dear to you in the prop design. Little things like this can make every project more personal and the end result will be more recognizably yours. I own a little leaf backpack that was the inspiration for the herb-collecting bag.

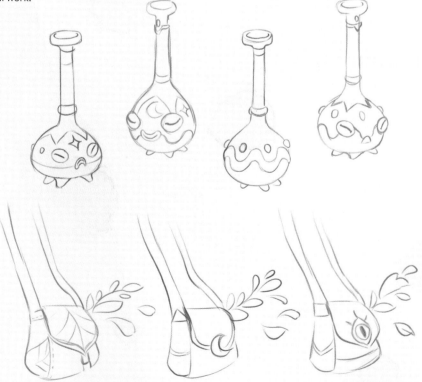

THE FINAL SKETCH

It's time to bring all our lovingly designed elements together and choose which combination works best. Try to balance the level of detail across the whole composition; don't cover your character with lots of rich detail from head to toe, as the viewer won't know where to focus their attention. I like to use two to five areas of greater detail, spread across some plainer sections of the design. Once the image is looking balanced and complete, it's time to say goodbye to the sketch and make cleaner line art for the painting process.

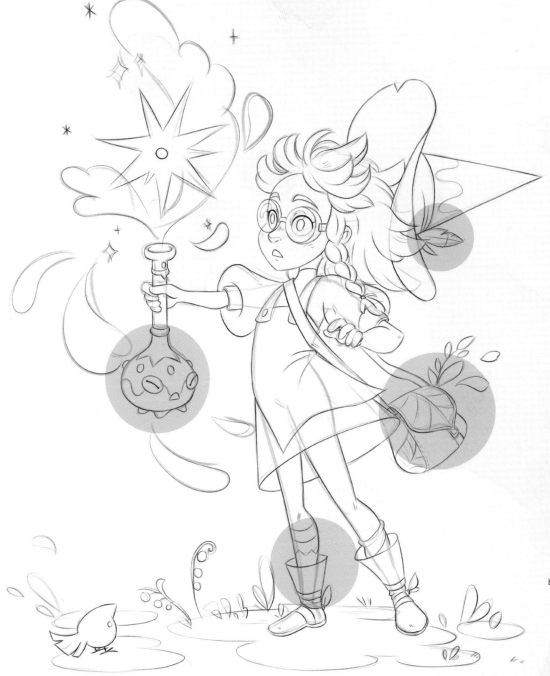

This page:
The final sketch brings all the design elements together

Opposite page:
Color is incredibly important, so take your time choosing

COLORS AND VALUES

Choosing colors is such a fun part of the process and also really, really important! A major aspect of coloring to consider is whether you want to fulfill certain expectations about the tones and hues you use, or whether you want to break some of these rules on purpose. The decision will depend on how you want your character to be perceived. If you want them to stand out, then give them bright and saturated colors full of contrast. I try out different versions of my character's look, from a classic black witch's dress through to a brighter dress with more color — and I kind of like them all! When in doubt, switch to grayscale and check the value and contrast of your composition to help you make the right decision.

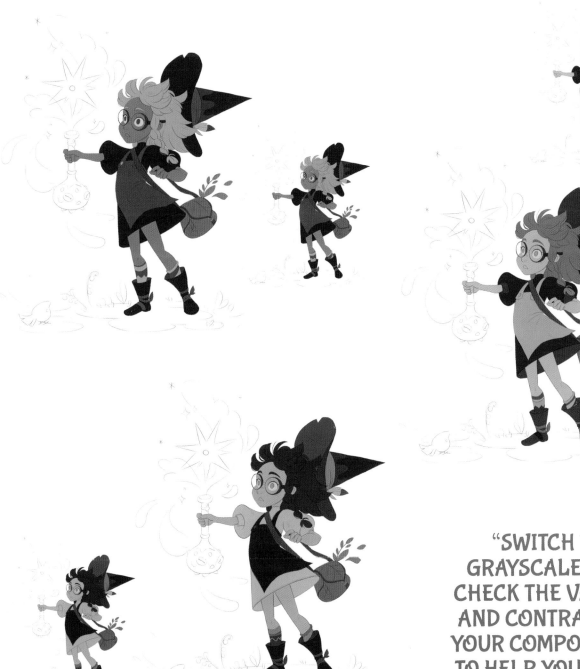

"SWITCH TO GRAYSCALE AND CHECK THE VALUES AND CONTRAST OF YOUR COMPOSITION TO HELP YOU MAKE THE RIGHT DECISION"

THE IMPORTANCE OF BACKGROUNDS

First impressions are important. I always like to present my character in an appropriate setting, with lots of action. Adding small details that indicate where the character is can help the mind wander deeper into the story. The background can underline the mood you are after — a bright background will be associated with something sunny and happy, while a dark background will indicate something evil or mysterious. I think it's fair to say magic is definitely more mysterious, so I place my character on a darker, muted background. This also helps to accentuate the magic exploding from the bottle. Since blue light rarely appears in the natural world, it always adds a layer of otherworldliness to a drawing — it also contrasts well with the apprentice witch's hair.

LET IT SHINE

There are several easy ways to add a shine or glow to a drawing. If you work in a traditional painting style, make sure you have enough contrast with the background so that shiny surfaces are the brightest part of the picture. For digital painting, adding a Color Dodge or Add effect layer will give any lower layers an arresting glow.

AN EXPLOSION OF IDEAS

The final step may involve the least decisions, but will take up a lot of time – this is when you set lights and shadows and paint details into the character. Spend this time thinking more about your character, really getting to know who you've created and their back story — befriend them! The more you think about your character, the more you might consider adding or removing little details. Nothing should exist in the final design without a reason. So, how does my apprentice witch's first day go? Well, she adds a rare blue forest flower to her first potion, causing a magical explosion, while her little raven companion sits at a safe distance watching the magic come to life. Luckily, the witch is wearing her safety goggles!

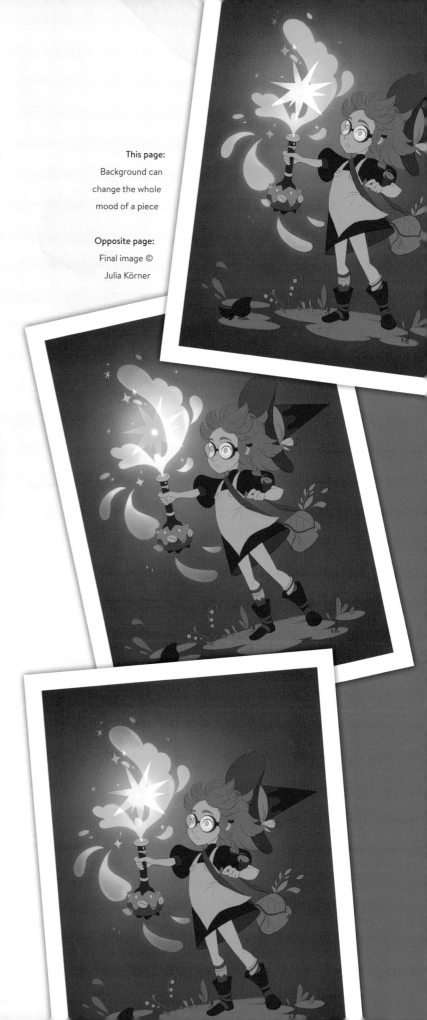

This page:
Background can change the whole mood of a piece

Opposite page:
Final image ©
Julia Körner

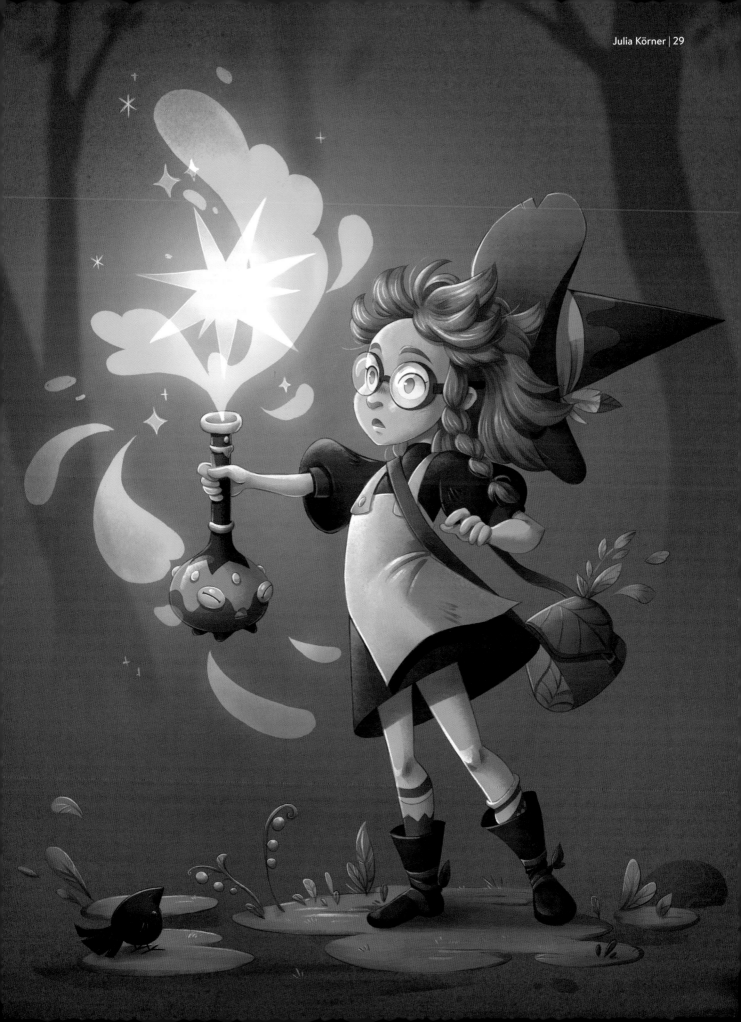

CHARACTERIZE THIS:
VILLAINOUS VEHICLE

ARCHINA LAEZZA

As a children's illustrator, I focus on creating characters that are appealing and fun for kids and trying to give them as much life as I can. Let me show you how to create a character from a simple two-word brief in a quick and effective way. I'm using Procreate on my iPad — let's begin!

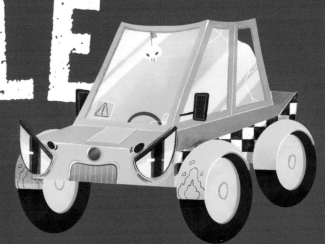

villainous vehicle

angry expression
punk/rock vibes
shabby/broken parts

a flying vehicle/a car
vintage/futuristic

BRAINSTORMING BEGINNINGS

The first step is take your brief and write down everything that comes to mind. Writing out your thoughts will help to organize your ideas and give a clearer mental image of your characters even before you start to sketch. And when I say write down everything, I mean everything, even things that seem trivial or off topic! Write it all down so you can free those ideas from your mind and move on to more original thoughts.

PICK A CAR, ANY CAR

Even if you have a clear idea of what your character is going to look like, sketch different options just to make sure you explore all possibilities. Often, I've found myself choosing a design that was in no way similar to what I had originally imagined! Play around with different shapes and start noticing which sketch appeals to you the most, and what is most fitting for the brief.

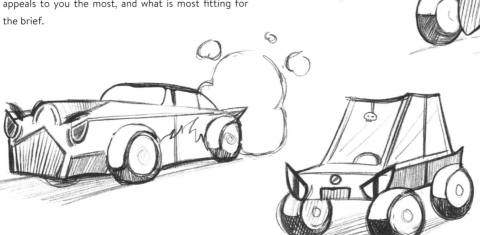

> "OFTEN, I'VE FOUND MYSELF CHOOSING A DESIGN THAT WAS IN NO WAY SIMILAR TO WHAT I HAD ORIGINALLY IMAGINED!"

PLAYING WITH POSES

Choose one of the sketches and redraw it in different poses and with different expressions. This helps you understand whether or not the character will work from different angles. It will also help you make it more dynamic and expressive. "Dynamicity" is a crucial element of any character design, especially so when designing for children.

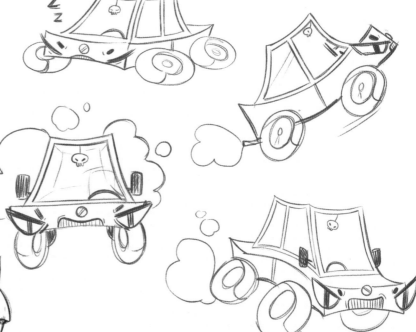

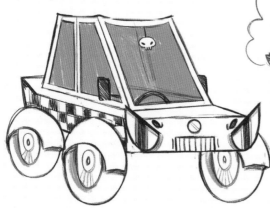

CHOOSE A PAINT JOB

When choosing the colors, create at least three thumbnails with different color palettes and compare them to see which one works best. Choose one dominant color for each palette, one dark color, one light color, and a color that contrasts with the dominant one. Be careful not to use too many colors during this phase and don't get lost in the details — the thumbnails need to be useful, not pretty!

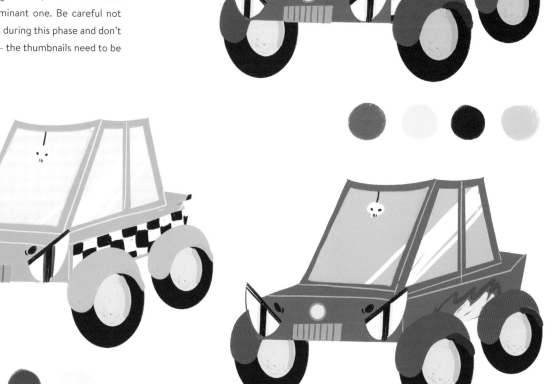

KEEPING IT WHEEL

With a color palette chosen, we can now lay down the flat colors accurately, and start to add textures and shadows to give the character dimension.

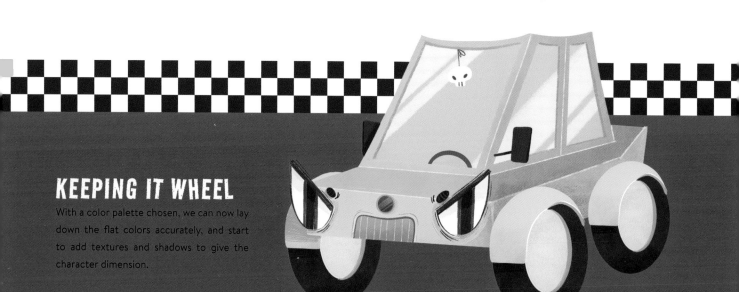

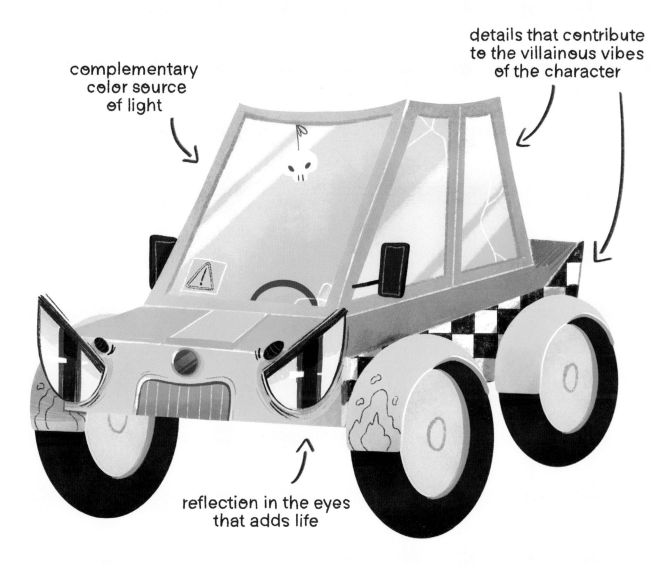

complementary
color source
of light

details that contribute
to the villainous vibes
of the character

reflection in the eyes
that adds life

A CAR IS BORN

All that's left to do is bring the character to life! Have fun with this last step, adding quirky details and captivating lights and shadows. Look back at the notes you wrote at the start of the design process and incorporate the best keywords into your design. And there we have it — in no time at all, we've taken a simple, two-word brief, and created a brand-new character from scratch!

MEET THE ARTIST
CARLOS LUZZI

Carlos Luzzi is a character designer and animator from Brazil who has worked with some of the biggest names in the industry on projects like *Klaus*, *Maya and the Three*, and *Mary Poppins Returns*. We caught up with Carlos for a fascinating chat about his career so far, the different skills involved in 2D and 3D art, and much, much more!

"I NEED TO UNDERSTAND HOW THE THINGS I DRAW WOULD MOVE IN THREE DIMENSIONS"

Hi Carlos, thanks for taking the time to talk to _CDQ_! Can you start by giving our readers a little background on your career in animation so far?

Hello! I got my start in the industry in the early 2000s, working in Brazilian animation studios, primarily on commercials. I didn't have the opportunity to attend an animation college. Still, I spent many years honing my skills as a self-taught artist and in art classes under great teachers like Glen Vilppu and Karl Gnass. Back then, I realized that you need to be an artist before being a cartoonist, a maxim that I think still holds true to me. I studied Graphic Design in college in Brazil, working on my animation portfolio in my free time. Eventually I was hired as an animator at a top Brazilian studio, and you could say that was really the beginning of my proper education!

Today, I realize how lucky I was to be part of the last generation of 2D artists in Brazil. The 2D animation collapse happened here five or so years after Disney shut down their 2D animation production in the USA. Some younger folks today might not know just how terrible a time it was to start out as a hand-drawn animator. After Pixar's success with films like _Toy Story_ and _A Bug's Life_, the whole world was turning toward CG production. I was in the USA at the time and saw the end of the 2D industry first-hand — I visited my friend Sandro Cleuzo in the Disney's Burbank studio and all the desks were empty, and the offices closed. Sandro was one of the last artists working in the building.

I started in Brazil in the 11th hour of 2D animation in the country and, to be honest, it was a great time. I had the chance to animate Warner Brother's characters, Tony the Tiger for Kellogg's, characters for Hanna Barbera and Cartoon Network, and many more. I animated a lot, night and day, and my skills grew with every project. Gradually, I started working for American animation houses, like Duncan Studio and Buttercup Pictures. Years later, I got the chance to work on feature films, and that's where I stand today.

You've recently worked on the film _Klaus_ and TV series _Maya and the Three_, as an animator and character designer, respectively. How did these two projects differ for you? Is there one role your prefer over the other?

I love animation as a whole and love both roles! In my career, I've had the chance to wear many different hats — besides animation and character design, I've also done quite a bit of storyboarding, and directed the pre-production of _Tainá_, a show for Brazilian Netflix. When it comes to animation and character design, you could say that one benefits from the other. As an animator, you need to make design choices (hopefully good ones!) at such a high rate that it becomes one of many skills that fit under the animation umbrella. Take, for example, Disney's "Nine Old Men", especially the work of Milt Kahl — in his animation you'll find every frame is a well thought out work of design, both in itself, and as part of a whole. You can definitely work in the animation industry without knowing

design at a sophisticated level, but to be a truly excellent animator, a deep understanding of design is essential.

As a character designer, knowing animation means I'm aware of the needs and limitations of a design, both stylistically and functionally. Sometimes, these factors won't matter and you can be more loose and stylized, depending on your approach. Many excellent artists create very stylized design — in fact, many have featured in *CDQ*! Being aware of the functional nature of animation puts me in a position where I can make informed choices that bridge the two extremes of design, between stylized and functional, bi-dimensional and volumetric. My work on *Maya and the Three* is a perfect example of this — I started with very stylized 2D graphic shape designs from Jorge Gutiérrez and Sandra Equihua and worked them into animatable forms, while concentrating on not losing the original look.

Working on *Klaus*, I had a different focus. As an animator, I'm creating the final performance that goes to screen, so I'm working on the acting level, and a style of drawing that must be believable in physical and emotional terms. I need to understand how the things I draw would move in three dimensions — I don't have a software tool to do this, I have to use my brains! This is when skills like controlling volumes, consistency, and understanding forms in three dimensions come in handy. Once you master these, you can perform as an actor, which is the final goal in animation.

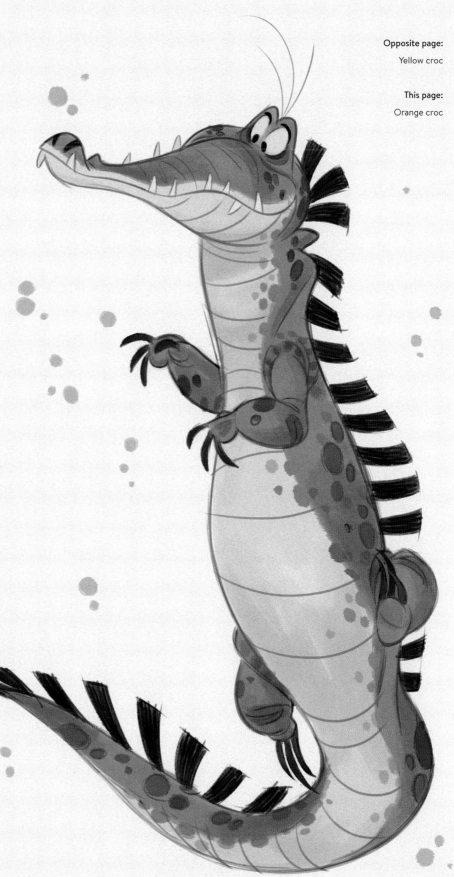

Opposite page:

Yellow croc

This page:

Orange croc

Your Instagram is full of bold and interesting characters. What do you think are the key elements of great character design?

I could answer this in a technical way, thinking about pleasant proportional relationships, an elegant balance between straight and curved shapes, line quality, or a perfect harmony between graphic quality and solidity. All these technical and artistic tools are essential and must be learned, but what makes a successful design is a set of choices guided by personal taste that can portray familiarity, individuality, and originality in a multi-dimensional way. In a world populated with hundreds of animated characters, a touch of uniqueness often manifests in very subtle details. In my experience, the most successful attempts come from deep exploration and thoughtful selection.

The process starts with drawing a lot from your own mind, then seeking references and inspiration from external sources, and finally panning for gold among all these ideas. Collaboration is a key part of good design, too, working with a director, producers, and art directors. It's not unusual that a director might like one very unrefined drawing, even a bad drawing, among the many attempts you make. This "bad drawing" might lack elegant proportions and can be a lot rougher than some of the other beautiful drawings you spent hours working on, thinking about every line and shape and proportions. But this crude drawing might reveal a unique personality or a touch of originality. What's great about working with a director is that he has a broader view and will always look at your drawings with fresh eyes, helping you channel the right character. I like to think the character designer job is similar to the casting director in live-action movies, but you get to draw the character instead of choosing from a large group of people. In both cases, you are looking for a unique personality to fill a particular role in the story, and you need to explore your options, dig deeper, listen to your taste and feel, and listen to the people around you.

You also seem to be a prolific sketch artist. How do the skills that make a great sketch artist translate into working on big budget projects?

I like the art of drawing, and I enjoy doing sketches for myself that are not necessarily animated characters. They can be human figures, animals of all kinds, locations that I think are interesting, rocks, the leaf of a tree, people, and characters from my imagination. All these could or could not be stylized in a language suitable for animation. I do this for many reasons. First, this is a way of continuously honing and improving my draughtsmanship, not locking myself into specific trends typical in animation. Secondly, this is a break from the usual animation mindset that is refreshing for an artist. And finally, I teach drawing. This links back to my study years with my beloved art instructors, Glen Vilppu and Karl Gnass.

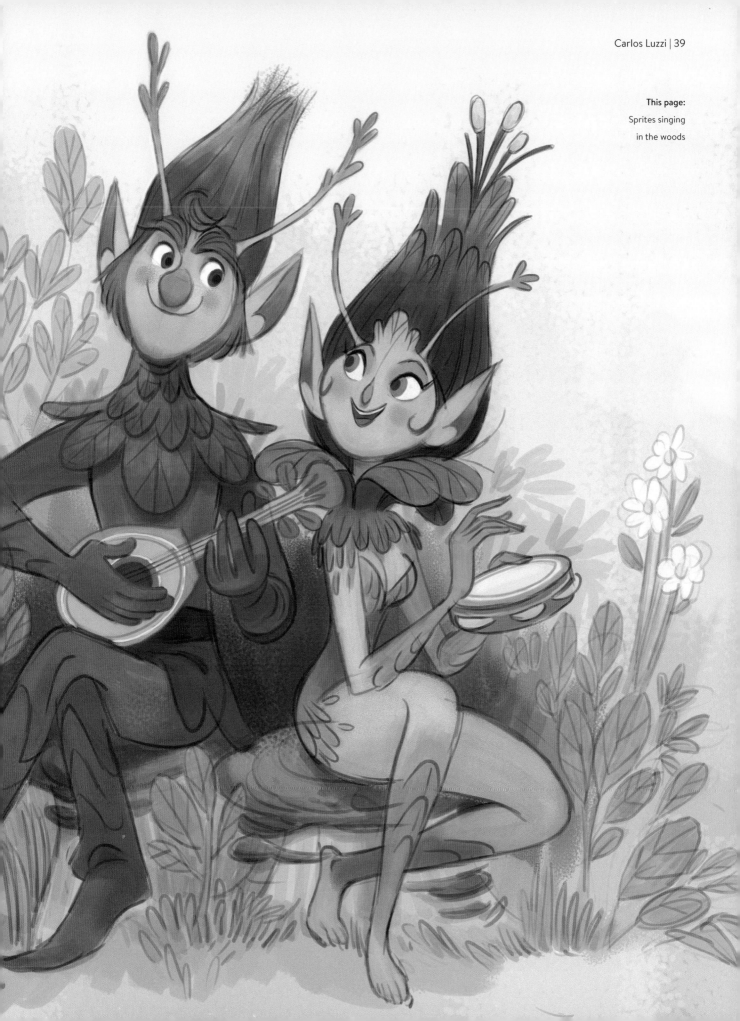

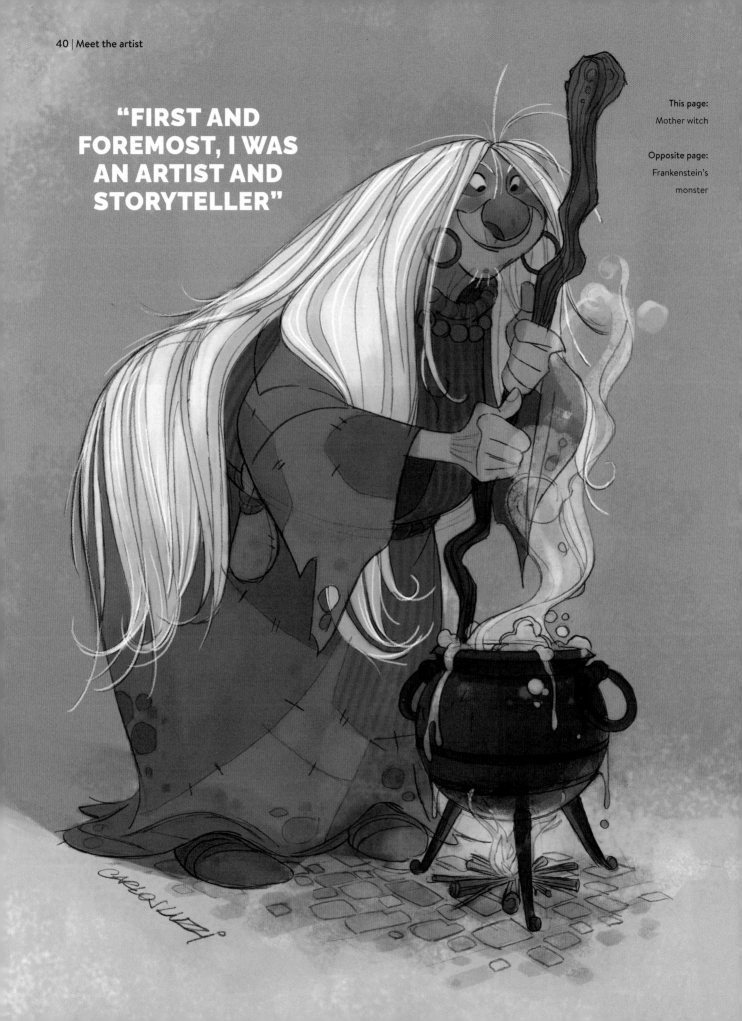

"FIRST AND FOREMOST, I WAS AN ARTIST AND STORYTELLER"

This page:
Mother witch

Opposite page:
Frankenstein's
monster

What were the biggest lessons you learned working with those two legendary artists?

From those formative years, I understood that, first and foremost, I was an artist and storyteller. If my medium was drawing, I should understand that as profoundly as possible. Before I lay down my pencil to animate or design stylized characters, I should learn simply how to draw. Most animation students tend to have a small taste of classic academic drawing, most of the time out of a curricular obligation — after college, they would start drawing stylized stuff and never look back. To me, it was the opposite; I was fond of that stuff and enjoyed drawing realistic subjects, especially with a pen in a sketchbook. And I'm aware it takes many years to learn it.

Maybe that's why I couldn't move to CG animation. I wanted to continue improving my drawing. Studying with Vilppu and Gnass and learning from the old masters in classic art and animation gave me the dimensions of how deep a subject drawing is. You cannot learn it superficially.

Do you think that some aspects of animating in 2D will be lost as the last of the pre-CGI generation gradually leave the industry, or are these techniques still being taught, maybe just in different ways?

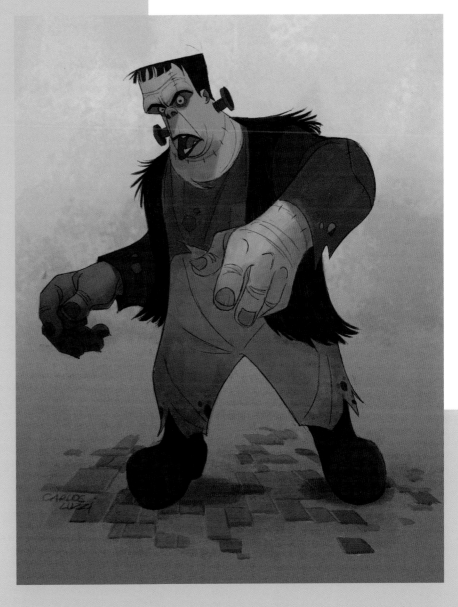

This is an interesting question. I would say that it will continue and change in the long run, but not necessarily die. It's a fact that CG animation has several attractive points for the industry, not least that it's much faster to train an animator compared to the years of study of a hand-drawn artist. On the other hand, CG has its limitations. Look at some of the latest CG movies that mimic the hand-drawn appearance to understand what I'm talking about. The process of animating 2D is manipulating lines and design, creating the 3D illusion. CG characters with a line filter on top can emulate

this look, but you can clearly see it's not the same. So, yes, I think there will always be room for traditional hand-drawn animation because it's so special and unique. Sergio Pablos was bold enough to make this very clear with *Klaus*, where they were able to merge a 3D render on top of the 2D drawings, and it ended up working beautifully.

Classical music and painting come to mind when I think about the life cycle of art forms. The music we consider "classic" was composed centuries ago, but there are still many people playing it. This style of music has also grown

and evolved alongside more modern forms of music — for instance, modern film soundtracks often have more in common with classical music than anything more modern. The same idea applies to renaissance "realistic" art, which disappeared as modern and post-modern art gained prominence. Still, realistic drawing survived and migrated to illustration and concept art. It's hard to guess the future, but I think people will continue to be interested in working with traditional techniques, and hand-drawn animation will find its way of changing to continue to exist.

Is there a single character design you've worked on that you are particularly proud of, and why?

Recently, I've been working on an upcoming movie called *Lord of the West* for which I made several designs that I'm very proud of, and were very fun to create. I'm particularly fond of "Yang Jian" — I can't tell you a lot about him yet, only that he has one eye on his forehead! It was challenging to come up with the right character design — Kyle Jefferson, our director, was looking for a very distinctive style for that character. Once we found the perfect combination of graphic qualities and unique personality, it set the tone for the other characters in the show.

Finally, for our younger readers who are keen to follow your footsteps and work in animation for film, what would be your number one piece of advice?

Draw a lot, from your imagination, and from observing the world around you. Continue doing it, even when you fail — especially when you fail! It's part of the process.

Don't compare yourself too hard with your Instagram timeline. Young people today tend to follow hundreds of artists. If you are not mature enough, you create a monster in your head made of all these fantastic drawings. It's cool to look at other people's work, but you must not lose yourself in this brilliant jungle.

It's like Odysseus stuck on Circe's island paradise in Homer's *Odyssey*. He was supposed to sail back home, but he stopped there for a while. It was so lovely, full of exquisite meals, and Circe was so pleasant and agreeable, he stayed a little longer, and a little longer still, and before he knew it, he'd been there a year. This is your Instagram timeline!

Looking at printed material is a different solution. That's how I did it. Looking at books and magazines limits the amount of material you see and gives you time to chew on it. Looking at an endless timeline just gives you the illusion of progress. When it comes to classes or online learning, it's key that you actually do the work, and develop the discipline to continue on it for as long as necessary. Avoid watching endless tutorials and never doing the work. You must do the work!

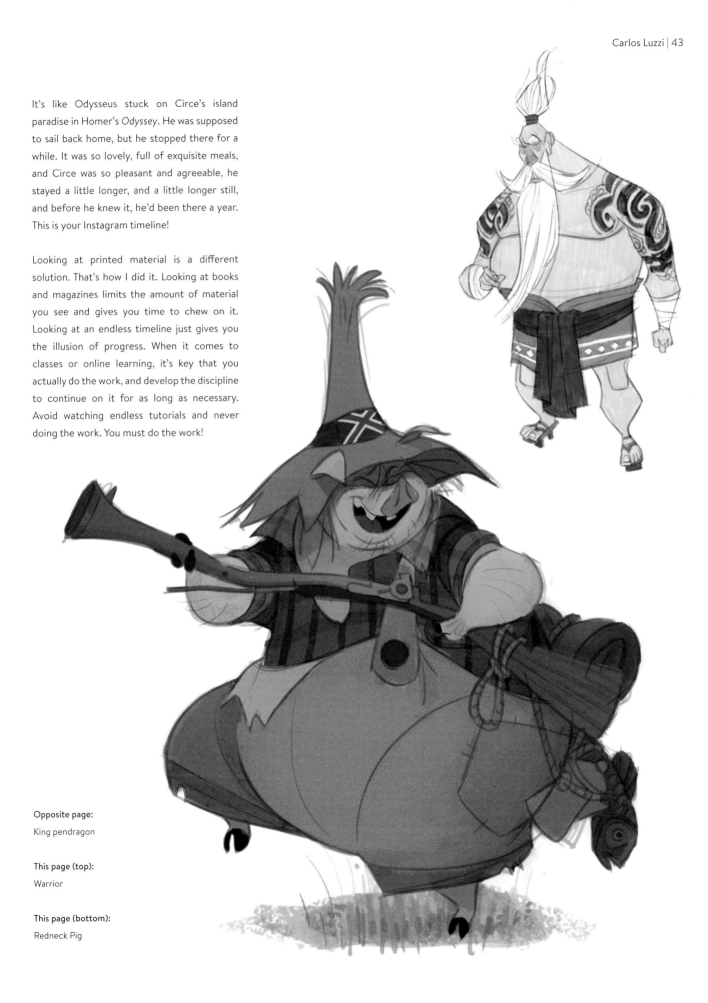

Opposite page:

King pendragon

This page (top):

Warrior

This page (bottom):

Redneck Pig

STYLIZING YOUR ART

JEANNE WONG

When drawing a piece, my key focus has always been on invoking "expressiveness" – finding a way to channel the mood, tone, and feel of the piece to the viewer. Finding three or four core elements of a piece to bring forward always helps me stay focused on the important details. It also helps the viewer to experience the same feelings I do when creating the piece. We'll be going over some of those processes in this article.

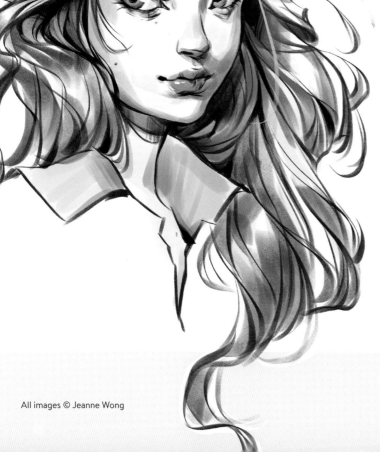

FORM AND FLOW

Consider the dynamism — what elements are "alive" on your character's design? Do they have especially wispy hair, or a favorite article of clothing that flares in an invisible breeze? Nailing the gesture of the forms is absolutely critical for the rest of the process.

COLLABORATION IS KEY

While creating work for clients, understand that most of them will approach you on the strength of your work. They see something in your style that they like, and they want to capture their vision in that style. Don't be afraid to interpret their vision in your way — but be respectful and ensure the client understands your interpretation as well.

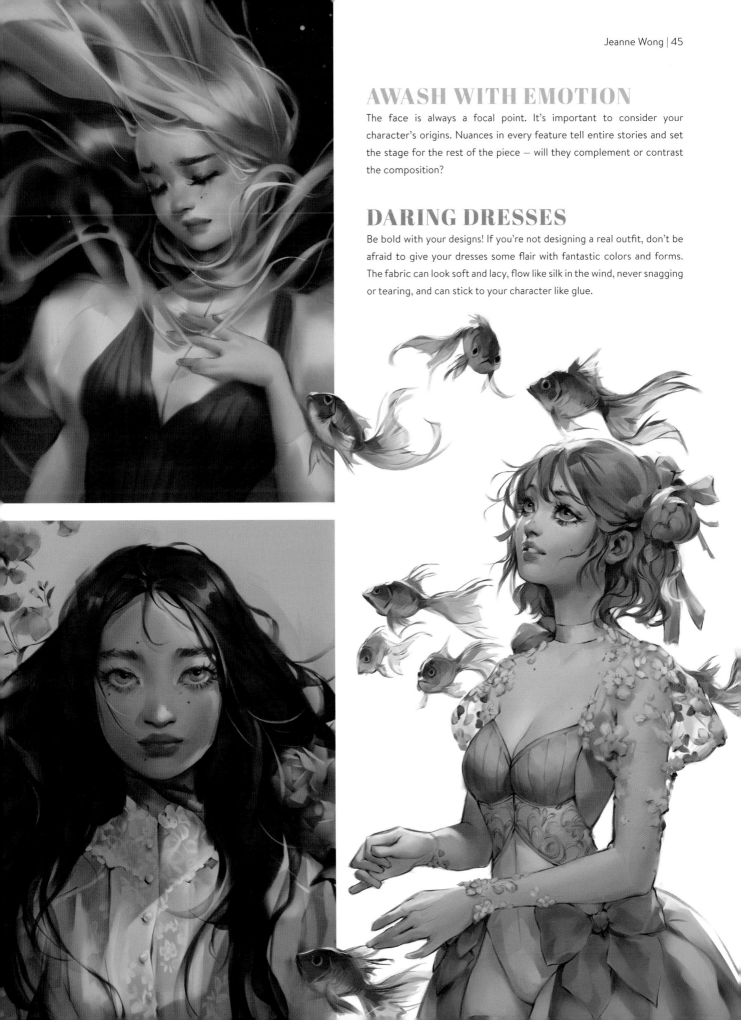

AWASH WITH EMOTION

The face is always a focal point. It's important to consider your character's origins. Nuances in every feature tell entire stories and set the stage for the rest of the piece — will they complement or contrast the composition?

DARING DRESSES

Be bold with your designs! If you're not designing a real outfit, don't be afraid to give your dresses some flair with fantastic colors and forms. The fabric can look soft and lacy, flow like silk in the wind, never snagging or tearing, and can stick to your character like glue.

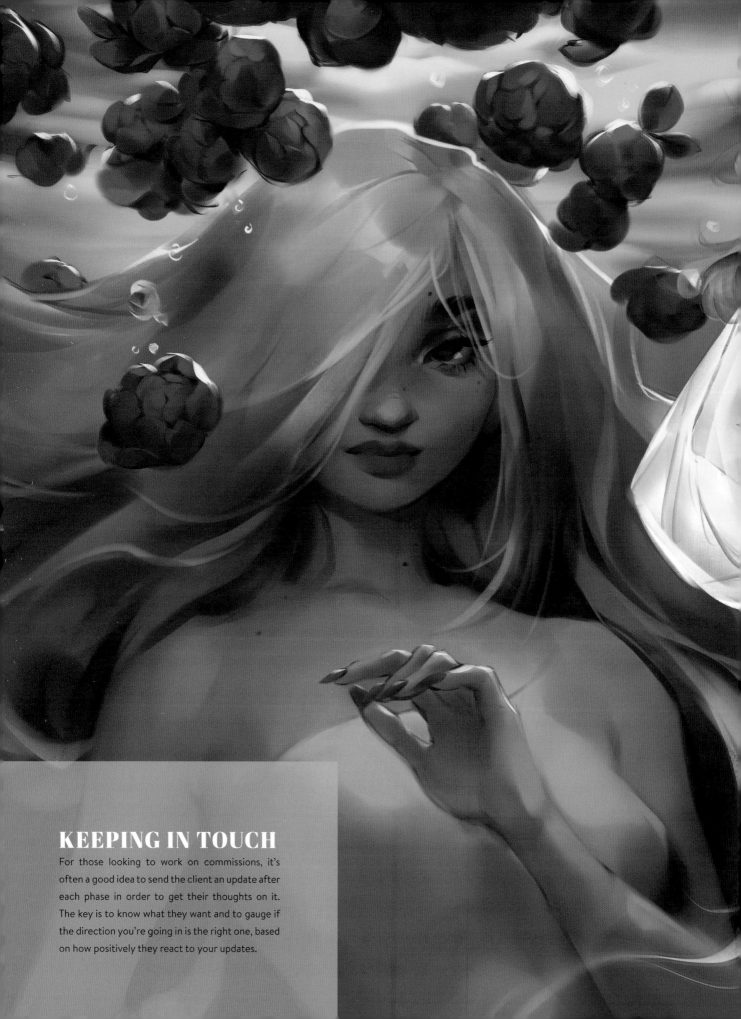

KEEPING IN TOUCH

For those looking to work on commissions, it's often a good idea to send the client an update after each phase in order to get their thoughts on it. The key is to know what they want and to gauge if the direction you're going in is the right one, based on how positively they react to your updates.

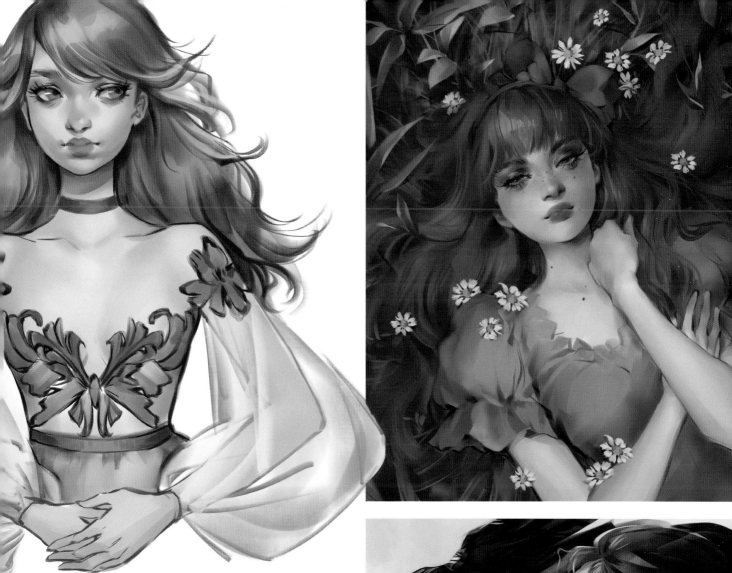

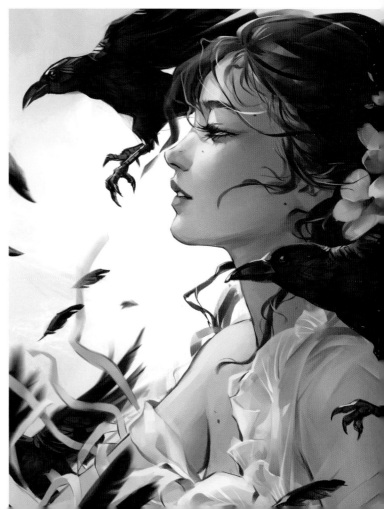

MIEN AND MOTIFS

One way of keeping a design, theme, or character trait consistent is the repeated use of a pattern or design. This can be as obvious as reusing a visual element for a hairpin, tattoo, or embroidery to something as subtle as a textile pattern, theme color, or method of dressing.

SIGNATURE STYLES

Over time, you may develop a preference for certain features and try to sneak some into every piece. Own that preference and make it your signature style! You don't have to add in every single style trait every time, but sometimes you might want to.

A DROP OF DRAMA

Every good scene needs some sense of awe or wonder. It can be an exaggerated feature like excessive petals, huge raindrops in the camera, or flying fish. Use them to frame the subject as well as to make things interesting.

HOW TO STYLIZE
CHARACTERS
WOUTER BRUNEEL

Every character is different, but the creative process behind them is often quite similar. Let me take you through my design process and explain all the steps I routinely go through when creating a character for either a single illustration or a game — in general, the process is messy and design choices are constantly evolving! *CDQ* provided me with three broad prompts: "merry musician," "graceful gardener," and "faithful friend." I decided to treat each of these separately but with a consistent style throughout.

I do the majority of the work on my iPad in Procreate, heading over to my Cintiq and Photoshop at the very end of the process to color-correct and fix my inevitable mistakes!

MERRY MUSICIAN

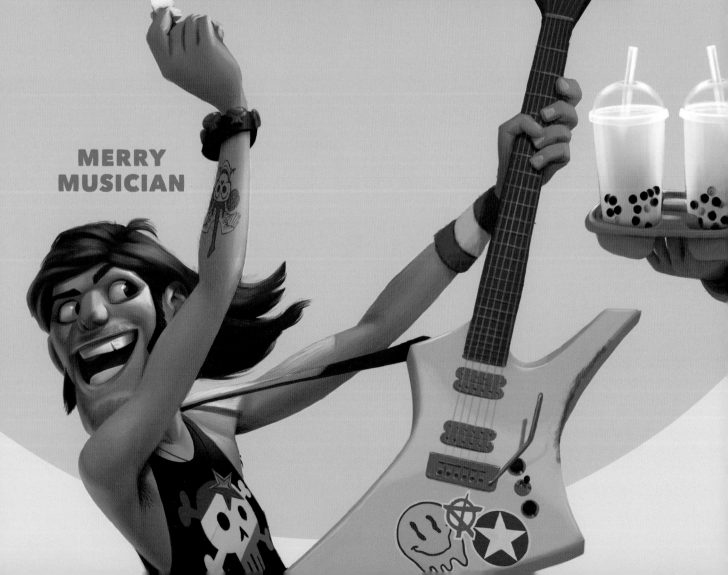

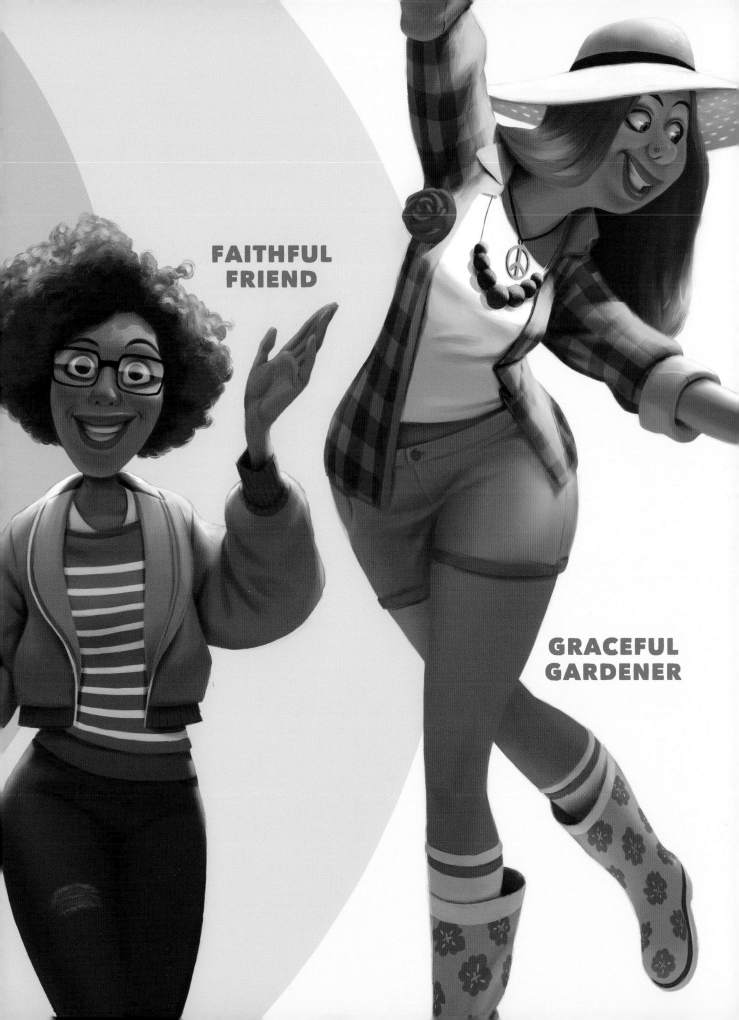

FAITHFUL
FRIEND

GRACEFUL
GARDENER

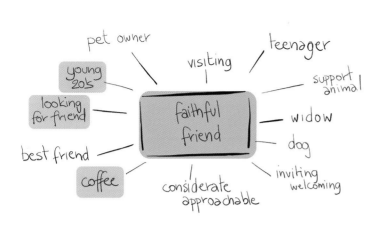

FREE THINKING

You have to start somewhere, and some free association around the provided brief will generate your first stepping stones. When you're brainstorming, anything goes! Often the most obvious visual element is the best place to start, especially for minor characters who need to communicate their purpose quickly. A main character will have multiple personality traits and more time to reveal them to the audience. Even if you have a strong initial idea, use this phase to consider other options.

GESTURE GENERATOR

Get to know your character by drawing loose sketches. Look for gestures that convey the vibe you are looking for. The pose, more than shape language or facial features, is where the character really materializes for me. A strong narrative pose will convey an awful lot of personality and can inform future choices. Don't get stuck on one idea – try to explore dramatically different directions.

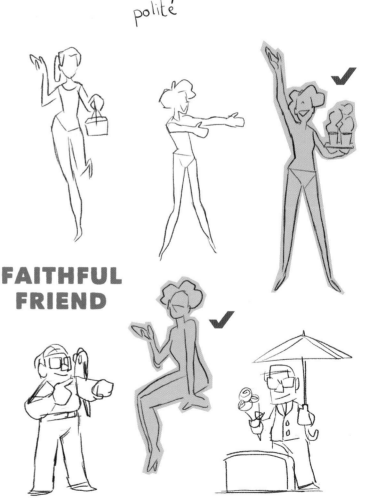

FAITHFUL FRIEND

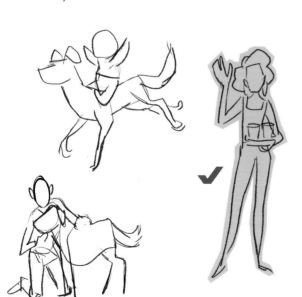

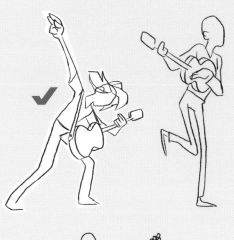

MERRY MUSICIAN

"A STRONG NARRATIVE POSE WILL CONVEY AN AWFUL LOT OF PERSONALITY AND CAN INFORM FUTURE CHOICES"

GRACEFUL GARDENER

Opposite page (top): Generate ideas freely! Don't get too attached to a particular direction just yet

Opposite page (bottom) and this page: Create gestures that convey story and attitude

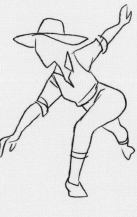

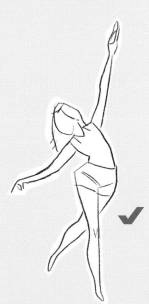

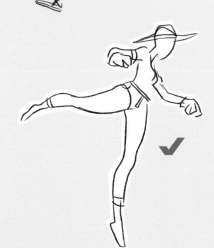

NARROWING

Based on your initial brainstorm and gestures, pick a specific set of characteristics that appeal to you and explore those further. Throughout the design process we will zoom in on every small aspect of our characters. Every choice along the way should result from quick visual experiments. Once you have a clear idea of the pose and broad type of your character, gather reference images to inspire your next round of sketching.

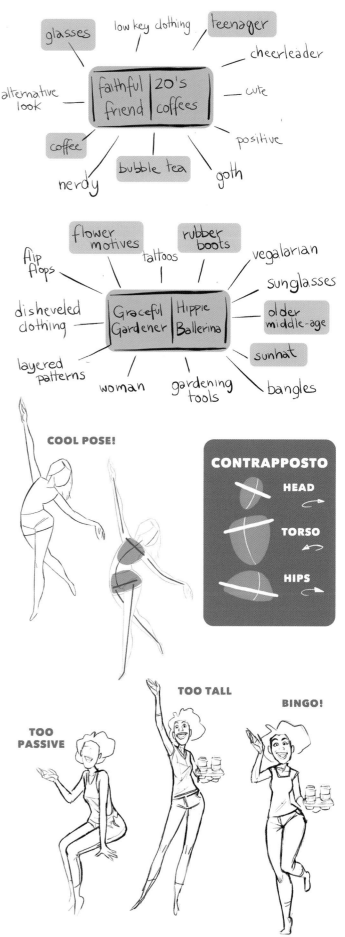

faithful friend | 20's coffees
glasses, low key clothing, teenager, cheerleader, cute, positive, goth, bubble tea, nerdy, coffee, alternative look

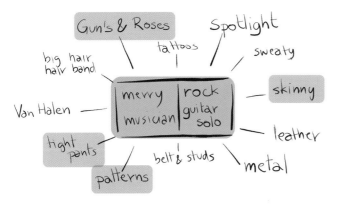

merry musician | rock guitar solo
Gun's & Roses, tattoos, Spotlight, sweaty, skinny, leather, metal, belt & studs, patterns, tight pants, Van Halen, big hair hair band

Graceful Gardener | Hippie Ballerina
flower motives, rubber boots, tattoos, vegalarian, sunglasses, older middle-age, sunhat, bangles, gardening tools, woman, layered patterns, disheveled clothing, flip flops

POSING

Now we know how we'll tackle the brief, it's time for another round of pose sketches. You are building a catalogue of visual options that can be cut up and recombined in order to find the right pose. In these sorts of illustrations, we need to make sure we get to see the full physicality of the character. Don't obscure the face or body through extreme fore-shortening or awkward poses. If the prompts were more action-oriented we would aim for a strong line of action. As it is, our characters are relaxed, so we'll prioritize poses that are balanced with contrapposto (counterpoised) to loosen up the figures.

COOL POSE!

CONTRAPPOSTO
HEAD
TORSO
HIPS

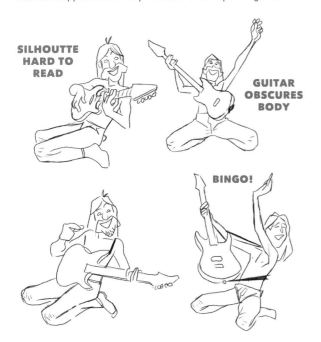

SILHOUTTE HARD TO READ

GUITAR OBSCURES BODY

BINGO!

TOO PASSIVE

TOO TALL

BINGO!

STOP, COLLABORATE, AND LISTEN

Always remember to show your work to peers, friends, or an art director — I cannot emphasize enough the value of feedback. This doesn't mean giving up ownership of your ideas, instead you are using a new perspective to catch errors that you will have to fix eventually any way. When I showed some of my early sketches to friends, they pointed out that the two women looked too similar. To resolve this, I decide to make the faithful friend a teenager. Actively seek out feedback throughout the design process to challenge your habits and highlight issues that have eluded you.

SILHOUETTE CHECK

Now that we have our poses, we need to figure out what our characters will look like. I made some initial choices concerning gender that I'm happy with. Create basic silhouettes to inform the build and body type of each of your characters. Use this step to push your designs away from the classic proportions — be subtle or go all out, depending on the style of the project. You can also use this phase to design the shapes of some big props and see how they influence the silhouette.

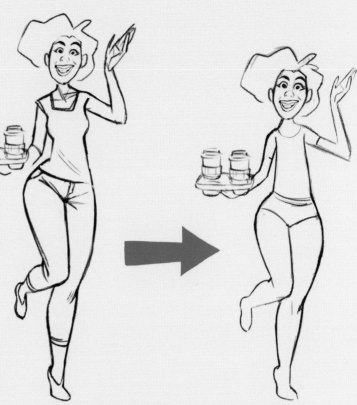

"USE THIS STEP TO PUSH YOUR DESIGNS AWAY FROM THE CLASSIC PROPORTIONS"

Opposite page (top): Narrow down the brief and start another brainstorm session

Opposite page (bottom): With a direction settled on, explore narrative gestures

This page (top): Don't get too attached to an idea — kill your darlings!

This page (bottom): A strong silhouette will make a character instantly recognizable

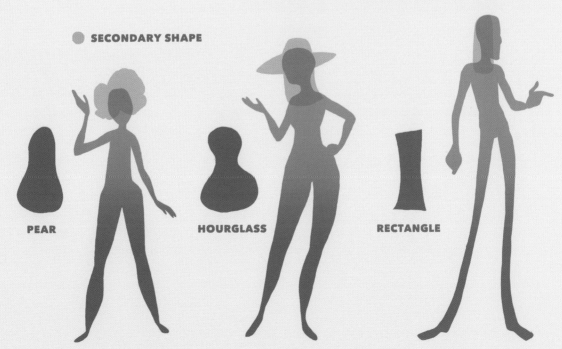

● SECONDARY SHAPE

PEAR

HOURGLASS

RECTANGLE

CREATE A FACE

By now you hopefully have an idea developing of the personality of your characters. My faithful friend is kind, considerate, and cute, without being a diva. The gardener is a bit older, content, and loves the outdoors. The merry musician is a bit wild and loves playing his instrument. Hit the internet and track down references that convey these personality traits.

You can reference performers, movies, social media – really anything and everything that inspires you! Once you have a mood board set up from your references, go back to the drawing board and find your character's face.

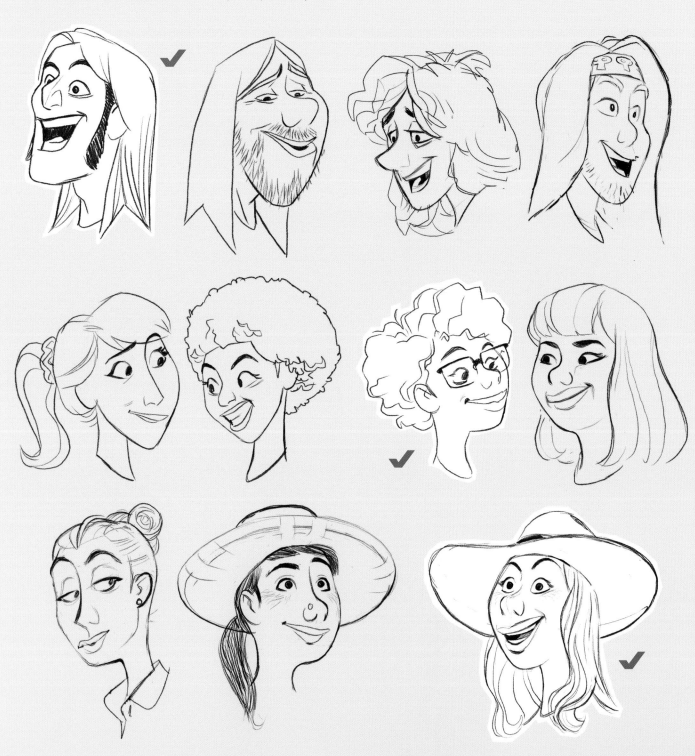

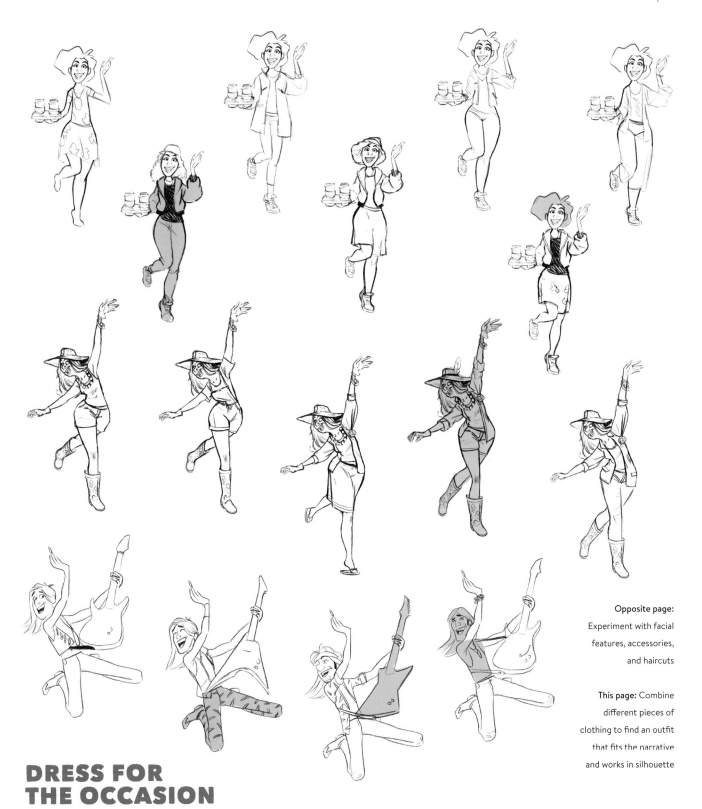

Opposite page: Experiment with facial features, accessories, and haircuts

This page: Combine different pieces of clothing to find an outfit that fits the narrative and works in silhouette

DRESS FOR THE OCCASION

Provided with a pose and a face, the characters have taken on very specific personalities. They have names and back stories, so now let's consider how they would dress. Take another look at your references or consider friends that have appropriate styles. Maybe ask a fashionista! There are infinite possibilities, but remember that the clothing choices you make need to have interesting shapes that create line breaks in one spot and smooth curves in another. Getting that balance right can be hard, but with practice it will become easier. Examine how your favorite artists balance their shape language and use simplifications to create appealing designs.

CLEAN IT UP!

With all the design choices made, it's time to create the final line art. It's important not to rush this phase — it's an opportunity to correct any "wonkiness" that has snuck into your design. Start by creating a structural underdrawing and break up your designs into simple basic volumes. Make sure your lines work with, and not against, these volumes, and fix any lines that break the illusion. Mirror your image to check for proportions that are asymmetrical, features that are off-center and shapes that are skewed. Any mistakes we can catch now before we render the drawings will save us work later on.

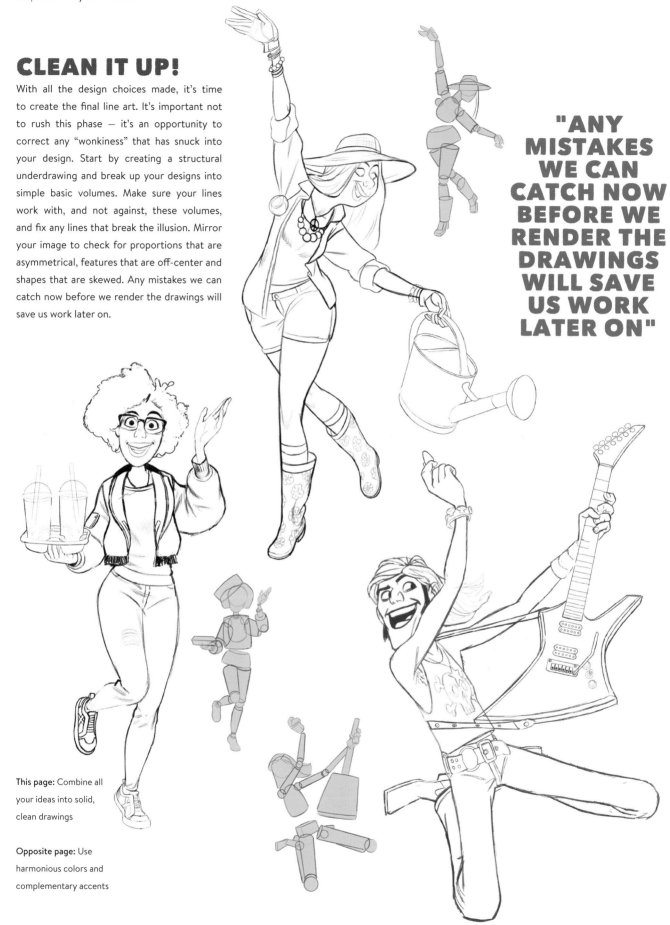

"ANY MISTAKES WE CAN CATCH NOW BEFORE WE RENDER THE DRAWINGS WILL SAVE US WORK LATER ON"

This page: Combine all your ideas into solid, clean drawings

Opposite page: Use harmonious colors and complementary accents

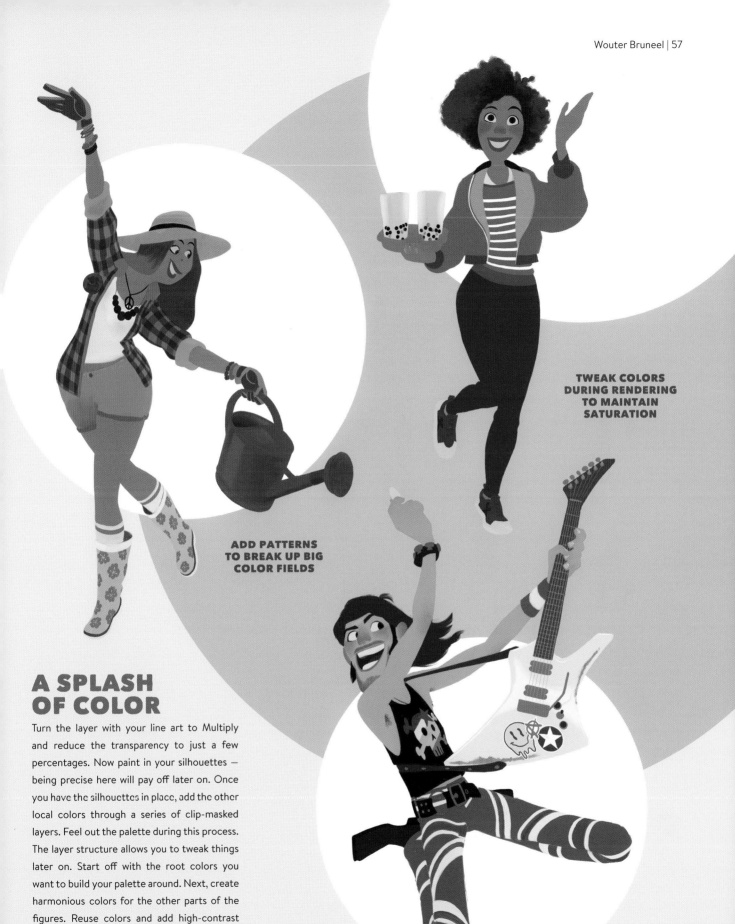

TWEAK COLORS DURING RENDERING TO MAINTAIN SATURATION

ADD PATTERNS TO BREAK UP BIG COLOR FIELDS

A SPLASH OF COLOR

Turn the layer with your line art to Multiply and reduce the transparency to just a few percentages. Now paint in your silhouettes — being precise here will pay off later on. Once you have the silhouettes in place, add the other local colors through a series of clip-masked layers. Feel out the palette during this process. The layer structure allows you to tweak things later on. Start off with the root colors you want to build your palette around. Next, create harmonious colors for the other parts of the figures. Reuse colors and add high-contrast complementary colors sparingly.

DRAMATIC LIGHTING

Use a Multiply layer to paint your basic shadow pattern. Remember to look for a continuous shadow shape and avoid creating small shadow "islands." Next, paint your key light with a Screen or Add layer. These two layers will set up the drama and focus we want to achieve with our lighting. It's good to establish this relationship early to avoid a lack of impact in your art later in the process. Experiment with colored light or extreme contrast but make sure they don't damage the readability of your design. For my trio of characters I used a simple warm white light and a cooler shadow hue.

This page: Aim for impact and drama with the key light

LIMIT EXTENT OF LIGHT TO FOCUS ATTENTION

CREATE IMPACT WITH YOUR KEY LIGHT

SWITCHING TO GRAYSCALE

Making sure your values are reading well and have sufficient contrast is vital. The fastest way to do this in Photoshop is to set your Proof setup (in the View tab) to "custom" and the Device to Simulate to "Working Gray – Gray Gamma 2.2." Now you can switch to grayscale at any time by pressing CTRL+Y. Press CTRL+Y again to go back to full color.

LIMITING THE USE OF LIGHT

Remember to create the highest contrast around the focus of your illustration. Your brightest light does not have to hit the whole figure. In real life, a light is often occluded by buildings, trees, or other people. Additionally, the intensity of most light sources decreases with distance. So we can limit our high contrast light, center it on the face of the character, and attract the viewer's eye.

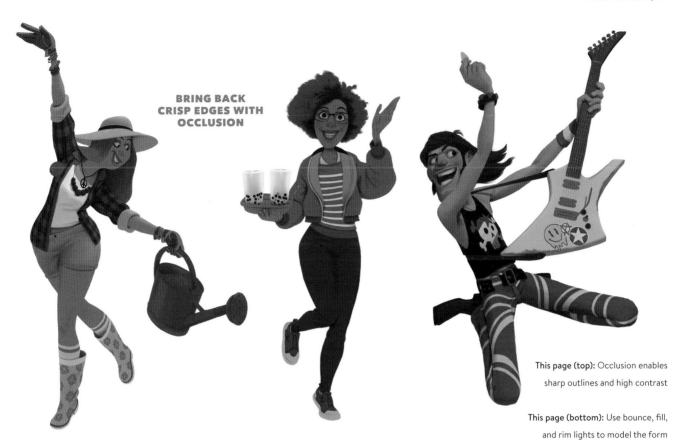

BRING BACK
CRISP EDGES WITH
OCCLUSION

This page (top): Occlusion enables
sharp outlines and high contrast

This page (bottom): Use bounce, fill,
and rim lights to model the form

OCCLUSION CONFUSION

Add another Multiply layer – on this layer we will paint the ambient occlusion. Occlusion happens in all the nooks and crannies of your volumes, between fingers and toes, under hats, and so on. You have a great deal of freedom in deciding how dark or smudged you make this effect. Occlusion is the best way to bring back the definition of drawing into rendered art. Use a warm-color medium tone in your occlusion layer and play with the opacity. Avoid pitch black occlusion as it can create spots of high contrast where they aren't needed.

RENDERING THE FORMS

Now we need to set up our secondary light sources. Use Screen layers to create a bounce light, fill light, and a rim light. These lights should be lower contrast than your key light. Remember the golden rule: your lightest shadow values should be darker than your darkest lit values. Keep your volume structure in mind and use soft and hard edges where appropriate. It depends on the environment, but most of the time, upward-facing planes will be cooler and downward-facing planes warmer.

RENDER VOLUMES WITH SECONDARY LIGHTS

MAKE EVERYTHING POP!

Experiment with the different lighting layers, adjusting their opacity or blending mode until you hit upon an impactful lighting setup. Play with your local colors as well, making sure there is enough vibrancy and contrast. Once you are happy, add some subsurface scattering, specular highlights, and reflections where needed.

THE FINISHING TOUCHES

Before we finish, we need to fix the mistakes we noticed during the rendering process. Duplicate all your layers and flatten them. Line art is forgiving and, once it's rendered, I always have to move a nose or shrink a chin!

Once our characters are tidied up, we can add some additional fun details. I make the gardener's hair a bit messy, add a tattoo on the musician's arm, and place a rip in the friend's jeans. Finally, add a soft drop-shadow to your characters to ground them in their environment, and our work is done. Now show this to your art director and hope for the best!

These pages:
Combine your light and shadow layers to create impactful illustrations, and add little details to strengthen the design

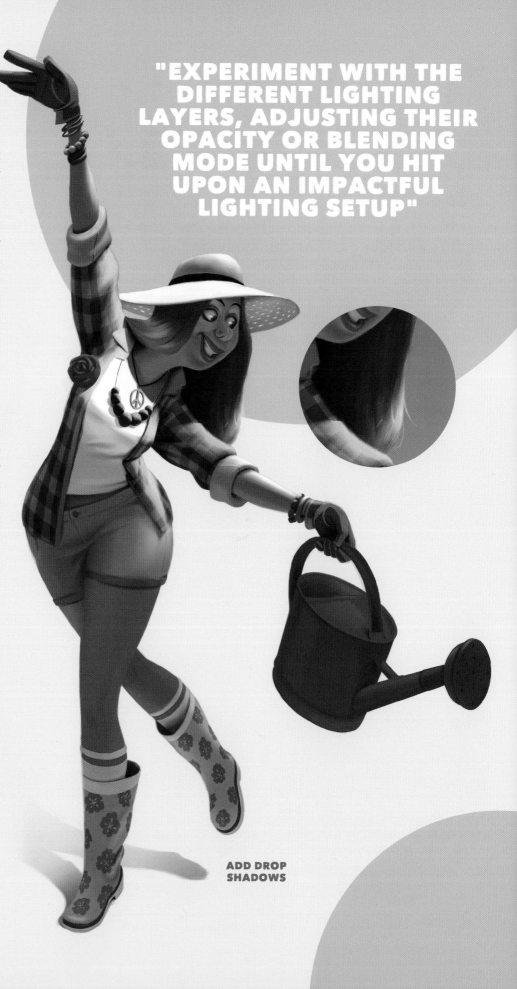

"EXPERIMENT WITH THE DIFFERENT LIGHTING LAYERS, ADJUSTING THEIR OPACITY OR BLENDING MODE UNTIL YOU HIT UPON AN IMPACTFUL LIGHTING SETUP"

ADD DROP SHADOWS

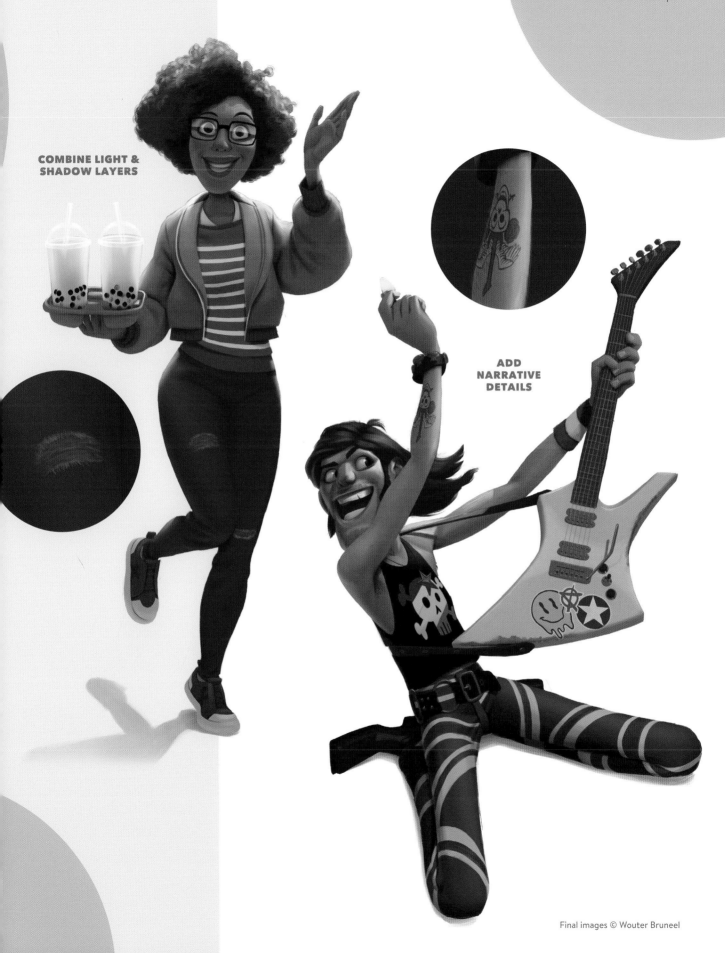

COMBINE LIGHT &
SHADOW LAYERS

ADD
NARRATIVE
DETAILS

Final images © Wouter Bruneel

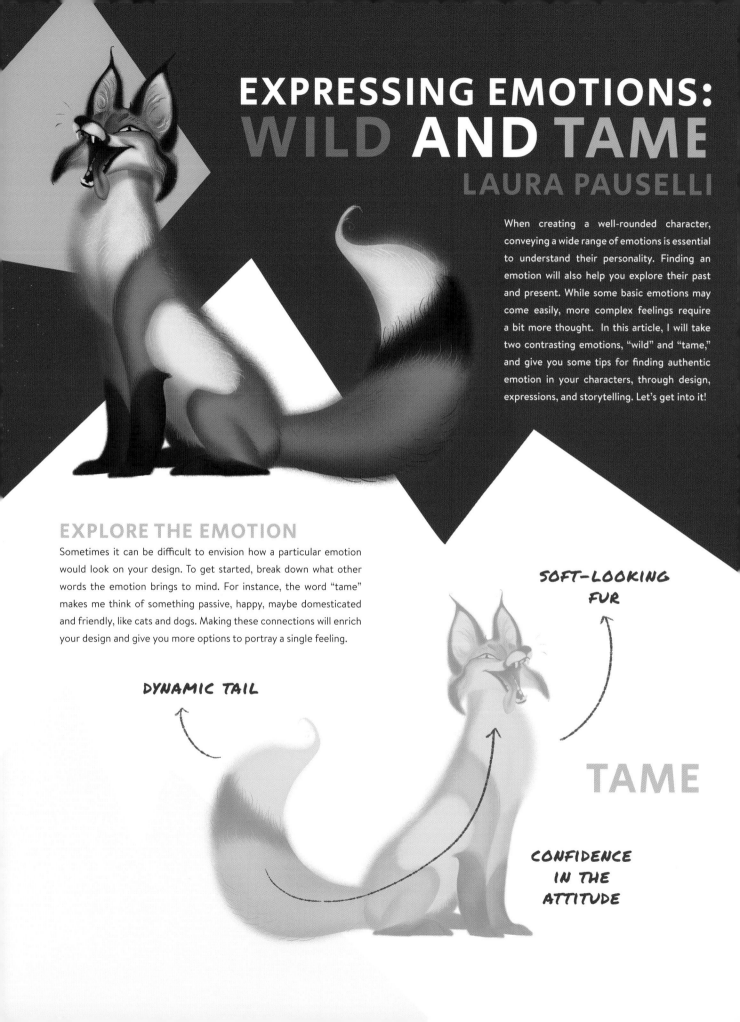

EXPRESSING EMOTIONS:
WILD AND TAME
LAURA PAUSELLI

When creating a well-rounded character, conveying a wide range of emotions is essential to understand their personality. Finding an emotion will also help you explore their past and present. While some basic emotions may come easily, more complex feelings require a bit more thought. In this article, I will take two contrasting emotions, "wild" and "tame," and give you some tips for finding authentic emotion in your characters, through design, expressions, and storytelling. Let's get into it!

EXPLORE THE EMOTION

Sometimes it can be difficult to envision how a particular emotion would look on your design. To get started, break down what other words the emotion brings to mind. For instance, the word "tame" makes me think of something passive, happy, maybe domesticated and friendly, like cats and dogs. Making these connections will enrich your design and give you more options to portray a single feeling.

SOFT-LOOKING FUR

DYNAMIC TAIL

TAME

CONFIDENCE IN THE ATTITUDE

IMAGINE THE MOMENT

Use your imagination to consider the moment in which we are encountering our creature. I ask myself, why is my red fox expressing wild emotions? I imagine it emerging from a bush at night, stopping and watching me with a mysterious, focused stare, before disappearing once again into the dark of a forest.

ROUGH LINES GO OUTSIDE THE MAIN SILHOUETTE (THEY HELP CREATE MESSY FUR)

FLOW OF THE SILHOUETTE LEADS TO THE FACE

"I IMAGINE THE FOX EMERGING FROM A BUSH AT NIGHT, STOPPING AND WATCHING ME WITH A MYSTERIOUS, FOCUSED STARE, BEFORE DISAPPEARING ONCE AGAIN INTO THE DARK OF A FOREST"

ELEGANT SILHOUETTE

WILD

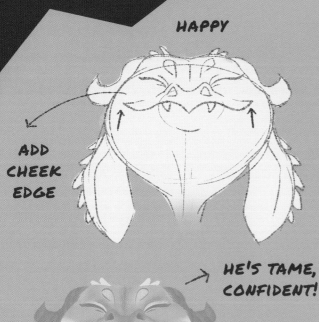

HAPPY

ADD
CHEEK
EDGE

HE'S TAME,
CONFIDENT!

SUCH
A GOOD
BOY!

LEADING LINES
POINT TO THE FACE

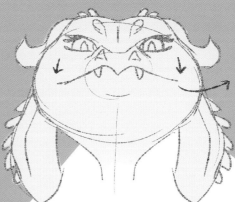

RELAXED

NO
CHEEK
EDGE

TAME

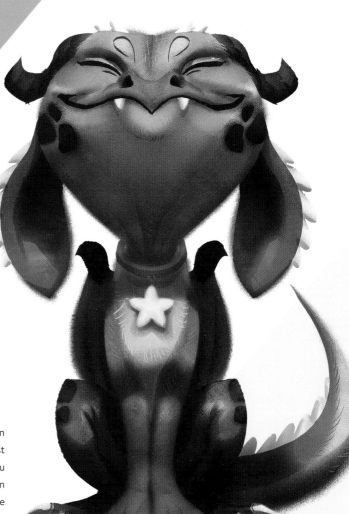

PROPPING UP
THE FEELINGS

Props added to the character can also help make the emotion appear clearer to the viewer. Every object added will suggest meaning, so make sure they fit with the overall emotion you are looking for. In this case, adding a collar to this cute dragon suggests that it is tame enough to live around humans – maybe he's someone's unusual pet!

WILD

OWLS OPEN THEIR WINGS TO SEEM BIGGER AND SCARIER

CURVED BACK

DEFENSIVE POSE

BUILDING A BACKGROUND

As well as considering the immediate surroundings of your character, exploring their background can also help you discover visual cues that will show your chosen emotion. Since I want my dragon to be wild, I imagined that maybe it had to fight for food and has broken its horn, or maybe its paws are dirty from playing in mud. Let your mind wander and you can discover so many story beats that will lead to a richer character design.

LOOK AROUND YOU

Inspiration can come from anywhere, especially the world around you! To create a tame character, observing pets can be a great source of inspiration. For instance, showing a character with their belly up is a perfect way to signal that they are tame – this is a common pose for a cat, but only if they're relaxed and trust you!

ROUND
SHAPES

TAME

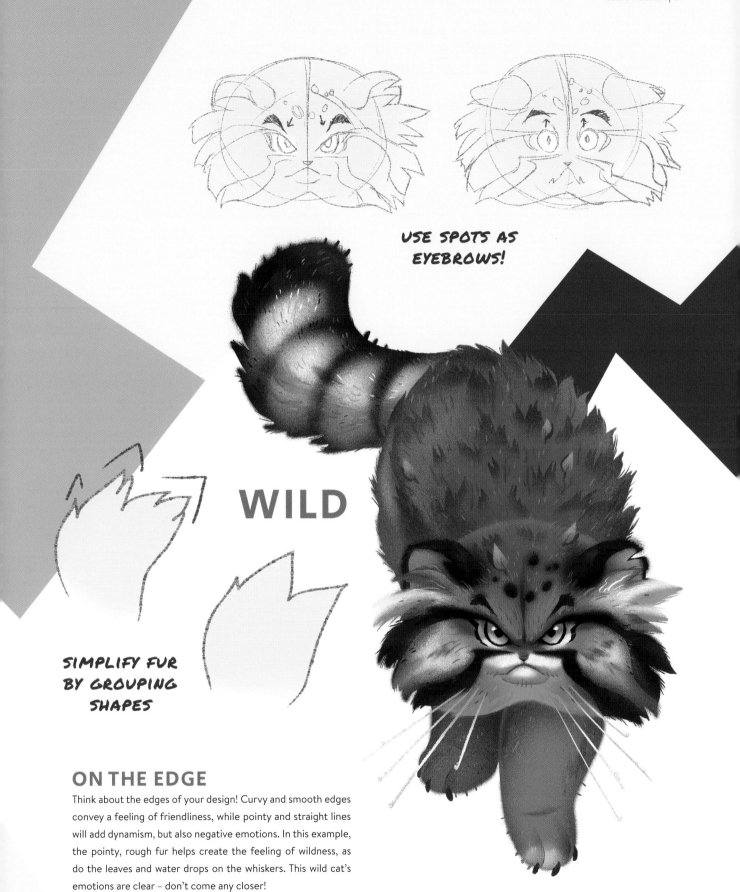

USE SPOTS AS EYEBROWS!

WILD

SIMPLIFY FUR BY GROUPING SHAPES

ON THE EDGE

Think about the edges of your design! Curvy and smooth edges convey a feeling of friendliness, while pointy and straight lines will add dynamism, but also negative emotions. In this example, the pointy, rough fur helps create the feeling of wildness, as do the leaves and water drops on the whiskers. This wild cat's emotions are clear – don't come any closer!

All images © Meike Schneider

MEET THE ARTIST:

MEIKE SCHNEIDER

Meike Schneider is no stranger to the pages of *CDQ*, having provided a fantastic tutorial in our last issue. A popular and prolific presence on Instagram, Meike's iconic character designs have been featured in children's books and even a fashion line. We caught up with Meike to discuss her unusual introduction to the industry, the pros and cons of social media, and much more!

"I HAVE BASICALLY BEEN DRAWING SINCE I COULD HOLD A PENCIL IN MY HAND"

Hi Meike! It's great to be able to interview you for *CDQ*. Could you introduce yourself to the readers and tell us a bit about your career to date?

Hello, thanks for inviting me! I'm a 3D artist, character designer, and illustrator based in Cologne, Germany. I mainly work in animation, design, and publishing, on projects such as children's books, character designs, product packaging designs, and sometimes even in fashion design.

I have basically been drawing since I could hold a pencil in my hand. My early work was heavily influenced by my favorite childhood TV shows, games, and movies. I still remember the day I watched the making of Disney's *Tarzan* on TV, seeing how Glen Keane animated the iconic character.

That was the first time I realized that being an animator is an actual job! From that moment on, I knew it was what I wanted to do. However, as time went by and the industry moved on, hand-drawn animation was mainly replaced with CG animated movies, so I adjusted my childhood plans slightly and wanted to become a 3D modeler. After I graduated and worked as a 3D Artist for a while, I wanted to do more than just model characters based on other

people's concepts and designs – I wanted to design my own characters and worlds, using my own ideas and imagination to create something that didn't exist.

I started learning digital painting and began to develop my 2D skills. I spent all my weekends and free time after work improving, and eventually I got my first few jobs in visual development and character design. Those jobs then led to other opportunities, and I was eventually able to quit my full-time job to focus on my freelance work. Today I am still working in 3D, and I teach 3D Modeling at a school, but most of my freelance projects are illustration projects.

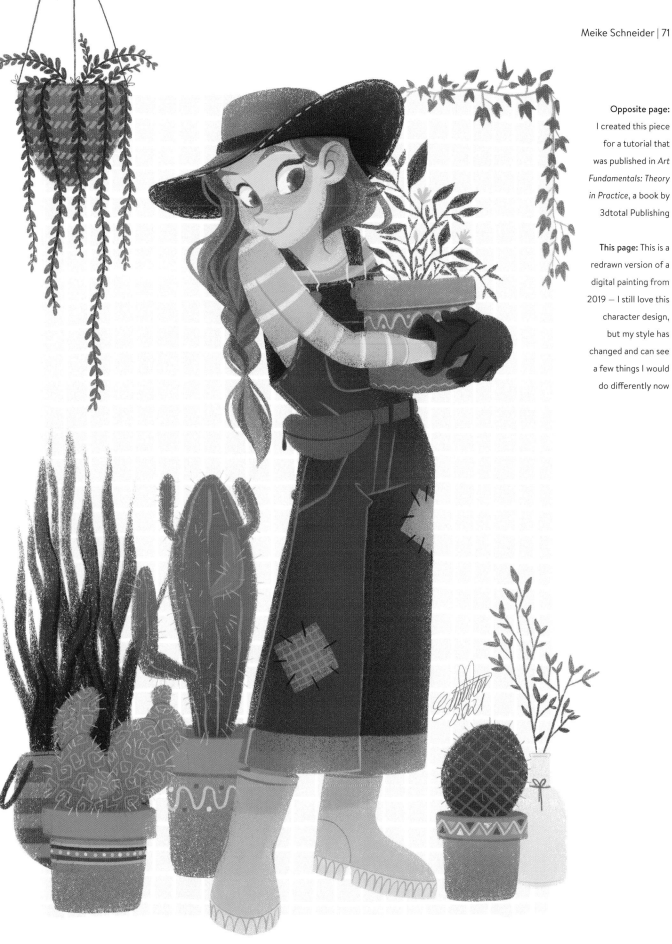

Opposite page:
I created this piece
for a tutorial that
was published in *Art
Fundamentals: Theory
in Practice*, a book by
3dtotal Publishing

This page: This is a
redrawn version of a
digital painting from
2019 — I still love this
character design,
but my style has
changed and can see
a few things I would
do differently now

You have a broad spectrum of experience, taking on projects in illustration, look development, and advertising. How does your approach to character design differ from project to project?

My approach always depends on how the client likes to work, but most of the time I suggest my way of working and the client agrees, or prefers a similar approach. Almost all my designs go through four stages during the process of creation: draft and layout, clean-up, color thumbnail and shape blocking, and the final render.

During the draft/layout stage, I start sketching various different rough characters, the client can then mix and match their favorites. After that, I always create a character sheet with a front, side, three-quarter and back view — this is so important and useful for later in the process, especially when out of your comfort zone and designing characters that don't look like your regular art style. You need to get used to drawing any new character correctly from each different angle and staying in "style." A character reference sheet helps so much with this! After that, I usually give the client different pose variations or camera perspectives (in case a background is included) during the layout stage.

Once the design or layout is approved, I usually start cleaning up the outlines next. I try to be as accurate as possible to avoid changes later in the coloring stage. I then block in colors super roughly with a bold brush. Sometimes, I'll give the client several different color variations, as the scheme can change the atmosphere of the entire image. Once they pick their favorite, I start outlining and filling shapes, although everything is still on separate layers so changes are easy to make. The last stage would be the final rendering of the image. Depending on the project, I skip or repeat certain steps, but the overall structure always stays the same.

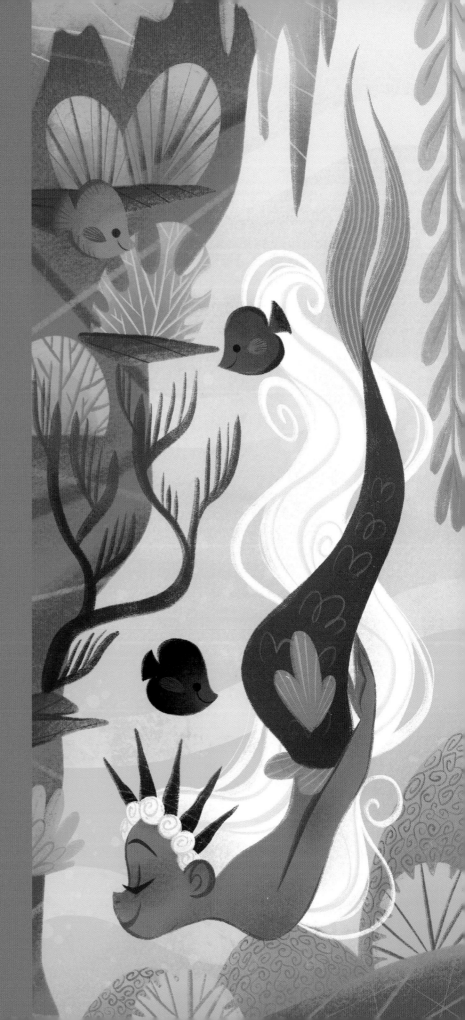

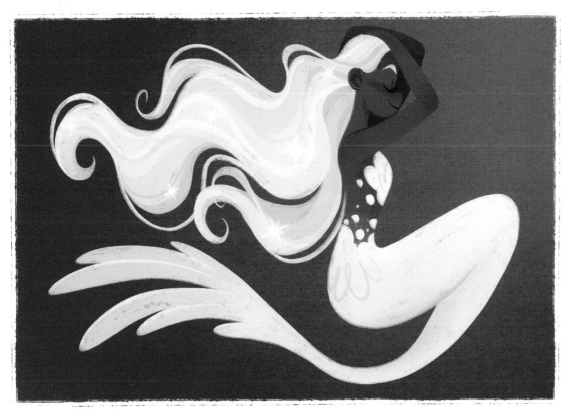

Opposite page:
I contributed this mermaid to Tom Bancroft's MerMay 2020 Art Exhibition at Gallery Nucleus in Los Angeles

This page: I drew this mermaid for the #MerMay challenge this year, focusing on simplicity and shape

I'd say the workflow is very similar for each different type of project I take, but obviously you are always designing a character to suit the specific audience. When working for children's books I have to keep the age range in mind. Children's book characters are mostly very stylized and colorful, while a character for package design needs to be simple in terms of shapes and details, and instantly recognizable.

It's rare that we come across a character designer that is also a skilled 3D artist. How does the one skillset help the other, and do you have a preference?

Yes, common wisdom is to pick one particular skillset and be really good at it, rather than being okay at multiple. However, learning 3D Animation as a student helped me a lot to improve my illustration and character design skills. I'd also say my art skills and style improved the most during and right after my 3D Animation studies. I still remember how creepy my first cartoon character model looked even though I thought I was a skilled traditional artist at the time! That was when I finally realized how important a basic understanding of anatomy is, and that there's still so much to learn — especially when it comes to characters in motion. How muscles move in certain postures is crucial for being a good character designer. Most traditional artists gain this knowledge from life-drawing classes, but I learned most of these skills from 3D modeling and using references. In 2D you can sometimes hide things, as the viewer only sees characters from a certain angle. However, in 3D every little detail needs to be perfect, as you will usually need to be able to show your model from *every* angle.

Even though I work mainly in 2D these days on the freelance side, I still use 3D as an aid when creating 2D projects. For instance, when working with a publisher for a children's book, it's very convenient to create a simple maquette for a character design, so you have a clear reference sheet from all angles. I also like creating very simple blockings in 3D to easily make changes to the perspective or even the base model. It allows the client more options for making changes as well, and helps them get a better idea of the shapes and perspectives I'm working with. And best of all — changes are super easy! For example, if I'm at the layout stage of a project, I can use my 3D blocking to give the client some different options for camera angles. Without a 3D model it would take me much longer to get the perspective right and make the image look visually appealing with clean outlines. Some of my clients aren't artists, so it's much harder for them to imagine how the sketch could look once it's fully rendered with proper outlines.

It's also very convenient to use the 3D image as a reference and just draw over it. Some might think this is cheating, but I think it's smart and saves plenty of time too! This technique also helped me to understand light. You can set lights in 3D and use this as a reference for accuracy — the more you use it, the more you understand how light behaves in 3D space.

I wanted to ask you about your amazing workspace. I've honestly never seen such an organized and calm looking studio. How does that impact your working day and help you as a character designer?

I'm a very organized person and I simply can't function when my workspace looks messy with things all over the place! My art studio is the room I spend most of my time in, so I want it to feel cozy and inviting. I feel much more inspired and motivated when surrounded by other artists' artworks and art books. As an artist you have good days, where it seems like every sketch turns out perfectly within minutes, but there can be bad days as well. You'll try to draw something and it always looks strange or simply wrong! Sometimes you don't even feel motivated or inspired at all. On days

like that, I love sitting on my sofa and flicking through art books by people who inspire me — my motivation always comes rushing back.

As I came to digital drawing later in life, I've managed to gather a whole load of traditional art supplies. A few years ago, I purchased an incredible, huge storage-solution cupboard, which really helped me organize my studio. It's called the Dreambox by Create Room and it is an absolute dream for people who love to be organized. I'm so glad I can finally stop searching endlessly for stuff I need — plus, it looks absolutely beautiful too!

Shape and color seem to be so important in your art. Are you very conscious of that, or is it something that comes naturally after years of practice?

Today, it probably comes naturally – well, perhaps just more easily rather than naturally! When I started with digital drawing, I tried to learn one thing at a time. I think that's a very efficient way to learn as it staves off any frustration. All these fundamentals can feel overwhelming for a beginner, I found it much easier to split disciplines into smaller portions and focus on one thing at a time until I felt confident in what I was doing.

I used the same technique with colors and shapes, too. I studied color schemes, looked at many examples, and tried to understand how to make very different colors look good together — for example, by using different saturation levels. After a while I felt much more comfortable and my color schemes seemed to be way more pleasing to the eye. The same goes for shapes — I spent time focussed on

"ONCE I WAS COMFORTABLE WITH THE FUNDAMENTALS, I STARTED TO BREAK THE RULES"

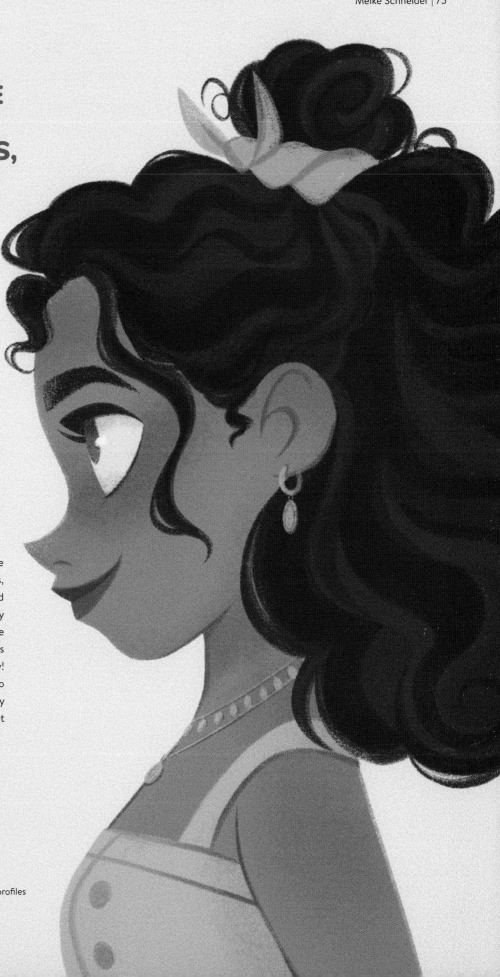

simplifying my characters, and then once I was comfortable with the fundamentals, I started to break the rules. Playing fast and loose with "proper" anatomy by using very soft and bended arms or legs can help create a nice dynamic flow in your characters. I guess what I'm trying to say is: experimenting is key! And, of course, tons of references. There's no better way to learn than to understand exactly what you like about certain artworks, or to get a pose right by studying a photo.

Opposite page: A mermaid created for #MerMay

This page: A self-portrait I use for my social-media profiles

It's really interesting to hear about your diverse route to becoming a professional artist. What advice do you have for artists struggling to find their artistic calling?

Do what you love, and focus on becoming really good at that one particular thing. Having a specific interest is super important for beginners — the more experience you gain, the easier it is to learn new skills and expand on your existing skills. For instance, if I'm really good at character design and I want to try integrating more environments into my artworks, then that's only one challenge to tackle at a time. If you try to do everything when you're a beginner, it's easy to become overwhelmed and you'll be slow to improve across every discipline.

For me, as an artist, it is very important to work on projects that I like and where I can see a chance to evolve. If I feel like my work is getting repetitive and my skills aren't developing then I'll try to change direction, maybe learn something new in order to open up fresh opportunities.

You maintain a very active Instagram account. How do you find it useful to further your professional career?

I've never been a person who's been super active on social media — in fact, up until a couple of years ago I didn't know much about Instagram at all! I lived in my own "art bubble," which is still a nice way to work, but I felt like my art changed and evolved much faster when I discovered Instagram and found other artists. I began to be inspired by other artists' techniques — maybe the way someone uses a texture or a brush, or perhaps the way another might draw certain facial features. Everyone is borrowing ideas from one another, and adding their own individual signature style to it. To be honest, most of the time this process seems to happen unconsciously.

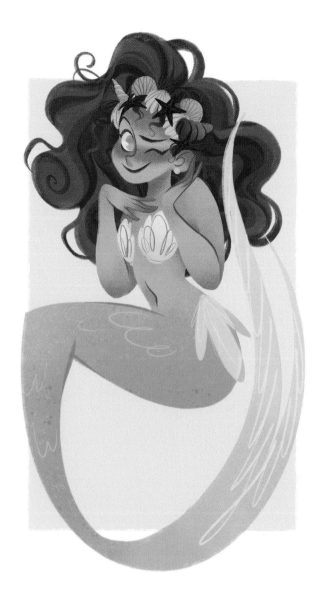

This page: The cover of my mermaid calendar and a #DTIYS (draw this in your own style) I hosted during MerMay 2021

Opposite page: A mermaid created for MerMay

The Instagram algorithm is constantly changing, and it seems like it's only ever getting harder to get recognition, but I'm still very grateful for the platform as it's given me many opportunities. Almost all of my clients find me via my Instagram, or my website, and now I'm in the enviable position of being able to say no to projects I don't feel comfortable working on.

I must admit that I don't post all the work I do for clients on my social channels — the artwork I post to Instagram is mostly things I create on my own time, between jobs. Instagram is all about consistency and recognition. I like to experiment with my style in my posts occasionally, adding more extreme lighting or something similar, but I would never post something as radically different as a photorealistic portrait, for instance. It's important to stay focussed art-wise on social media, as the audience wants to connect with a consistent style.

Thank you so much for answering our questions, Meike. It's been a pleasure to have your amazing art in *CDQ* again.

Thanks so much for having me! It's been a pleasure, I hope some of your readers can take something useful from my journey.

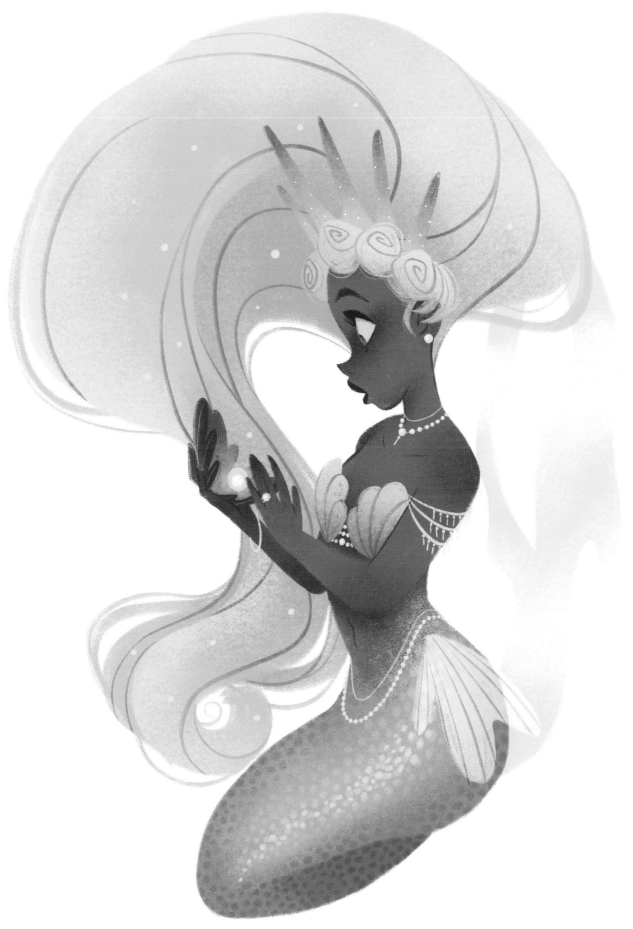

THE GALLERY

In the gallery we present a fresh selection of art from talented individuals from all across the industry. In this issue we have pieces from three exciting artists, Alex Relloso, Yannan Shi, and Martin Zahradník.

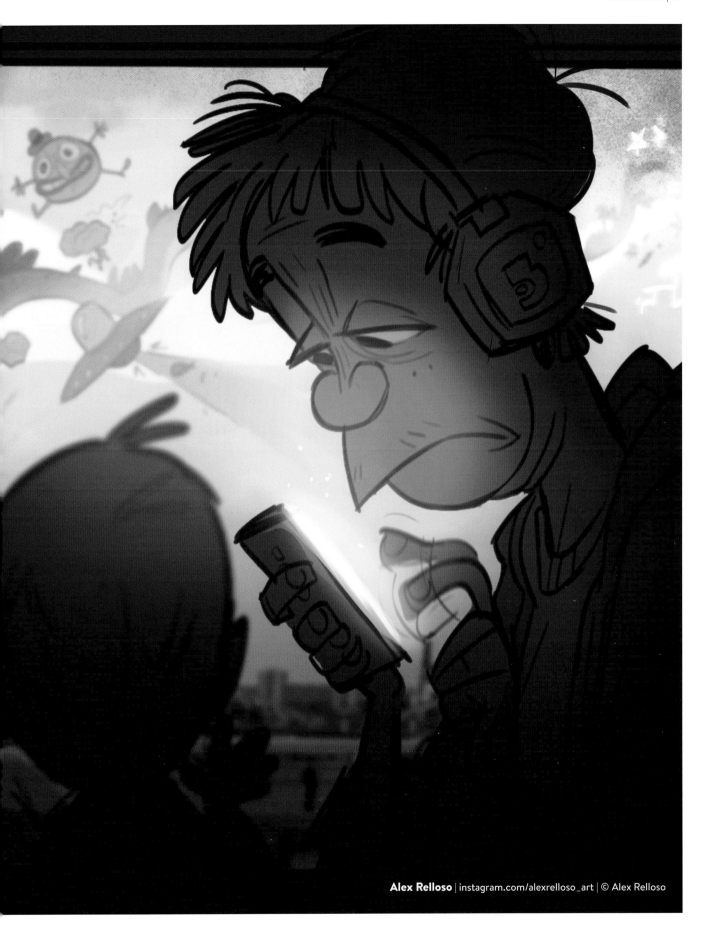

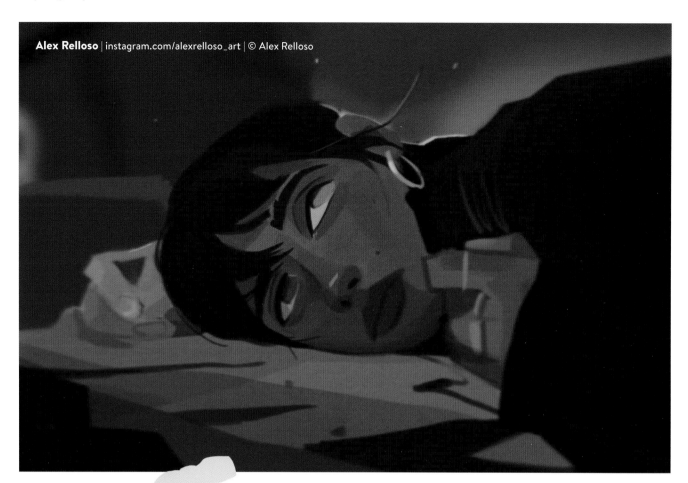

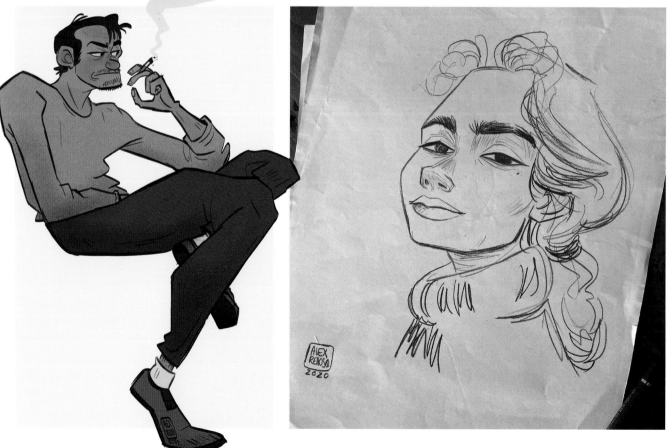

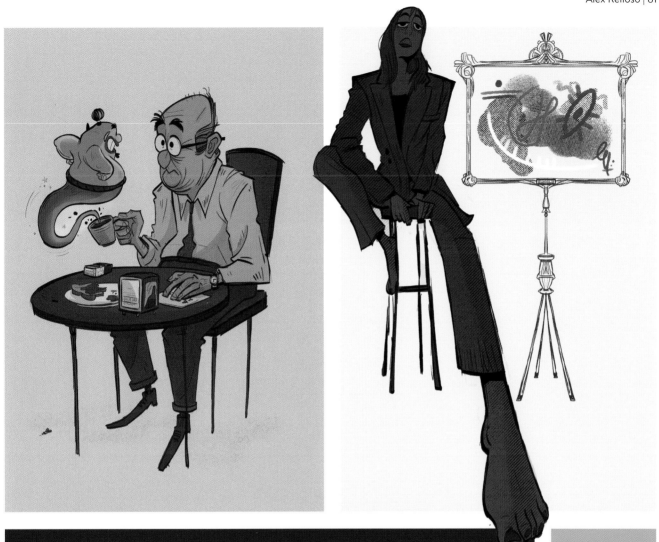

ALEX IS A STORYBOARD AND CHARACTER-DESIGN ARTIST FROM
MADRID, SPAIN, CURRENTLY WORKING AT THE SPA STUDIOS.
HE LOVES SKETCHING OUTDOORS WHILE ENJOYING A CUP OF COFFEE.

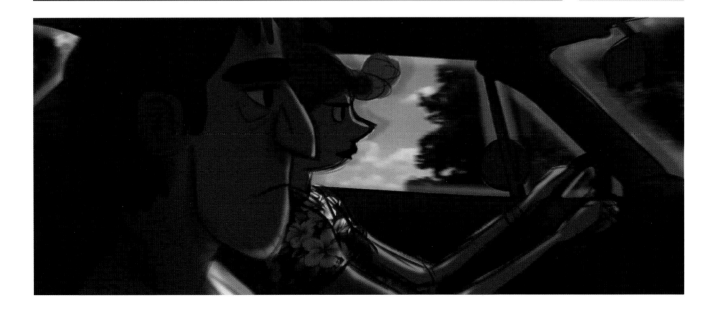

Yannan Shi | drawnbyyannan.com | © drawnbyyannan

YANNAN IS A SELF-TAUGHT COMIC CREATOR, EDUCATOR, AND ILLUSTRATOR, CURRENTLY LOCATED IN MONTRÉAL, CANADA. AFTER WORKING IN EDUCATION FOR SEVEN YEARS, SHE TOOK A LEAP OF FAITH TO BECOME A FULL-TIME ARTIST. SHE LOVES TO CREATE WORK THAT IS DREAMY, SURREAL, AND WHIMSICAL.

MARTIN ZAHRADNÍK IS
A DESIGNER, 3D GRAPHIC
ARTIST, ILLUSTRATOR,
AND VISUAL DEVELOPMENT
ARTIST. HE LIVES WITH HIS
WIFE AND TWO DAUGHTERS
IN THE CZECH REPUBLIC.
HE IS CURRENTLY WORKING
ON HIS SECOND ANIMATED
FEATURE FILM, *PEARL*.

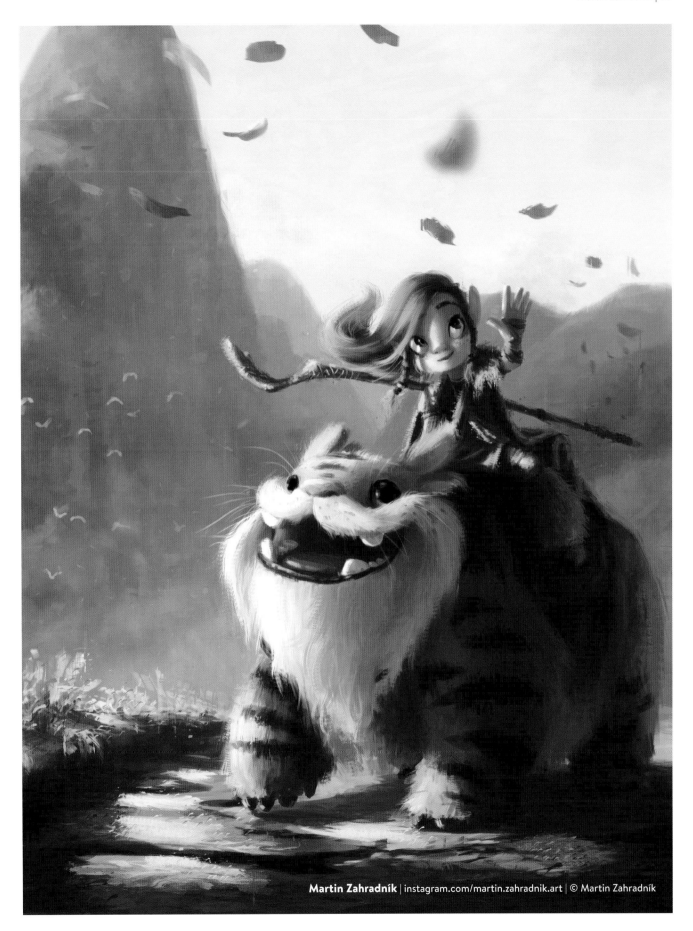

REIMAGINING
BABA YAGA
DOM MURPHY

Putting your own unique twist on characters from folklore and fairytales can be a fun and rewarding exercise. For this article, I was asked to put my own spin on Baba Yaga, a witch from Slavic folklore who flies around in a mortar and pestle! Let me take you through the entire process, from early concepts to an industry-standard character, ready for animation!

TIME TO SKETCH

When beginning a new project, it's always a good idea to start with a round of sketches, brainstorming and getting an idea of what the character and project will entail. I begin by drawing a few simple versions of Baba Yaga and deciding which looks worth developing.

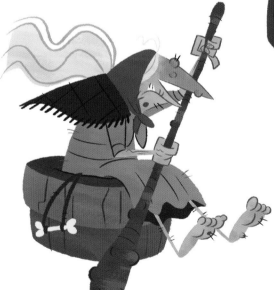

WHICH WITCH IS THIS?

Proper research can mean the difference between a good design and a great one! With a character like Baba Yaga, I want to stay true to the Slavic folklore tradition of a witch flying around in a mortar and pestle, but also include nods to other aspects of Slavic culture. Loosely basing my character's design around Matryoshka nesting dolls not only adds a nice cultural reference point, but the shape suits the character nicely – the top half of the doll will be the character, and the bottom the mortar and pestle! I also discover that Baba Yaga features in many children's stories, so it might be a good idea to ensure her final design isn't too mean.

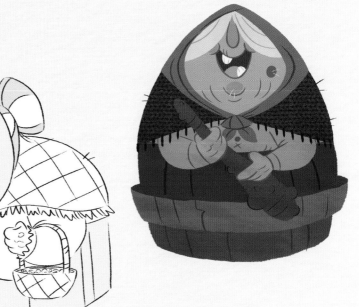

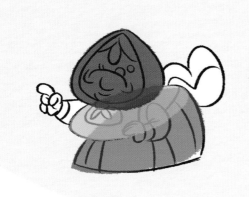

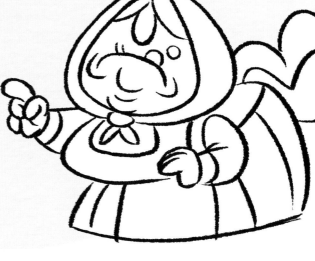

THE SHAPE OF THINGS TO COME

When developing a character, shape science can be a huge asset in helping you define not only their look, but also their personality. For instance, Baba Yaga is generally portrayed in folklore as a villainous character, so leaning toward sharp, long shapes would be the traditional approach – but maybe a rounder shape might lead to some fun design and story choices. She won't appear as harsh, which in turn might help her to lure unwary travelers to their doom!

All images © Dom Murphy

CHOOSING A DIRECTION

Now that we've got most of the initial brainstorming out of the way, it's time to pick a direction in which to take the character. Do we want to go dark and moody, or have a lighter and softer approach? Here are two very different versions of the character: in the first sketch I've stayed truer to the traditional portrayals of Baba Yaga, and in the second I've given her a friendlier look. For this project, I want the best of both worlds – I want the design to be true to tradition, but not too dark, so it appeals to a wider audience.

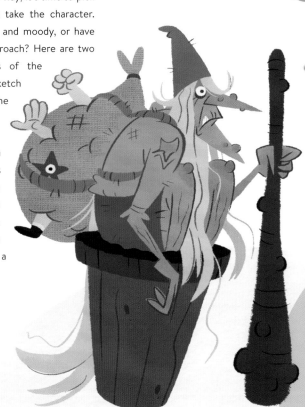

HEAD SHAPES

One of the best exercises for exploring designs when creating a character is to experiment with head shapes. As well as helping you to understand where you might want to take the character, sometimes you can build a whole character from a head shape doodle alone. It's also a great warmup exercise!

DECISIONS, DECISIONS

Next, we need to refine Baba Yaga's design into something resembling a final form. Keeping everything in mind we have discussed so far, this is where we really start to define the character. My first attempt is a bit too compact — we want her to be soft and resemble a nesting doll, but we also have to keep in mind that the character needs to be functional for animation purposes. The second design is richer and will be easier to animate.

"HAVE FAITH IN THE DESIGN PROCESS AND YOU WILL ALWAYS GET TO WHERE YOU'RE TRYING TO GO WHEN CREATING YOUR OWN CHARACTERS"

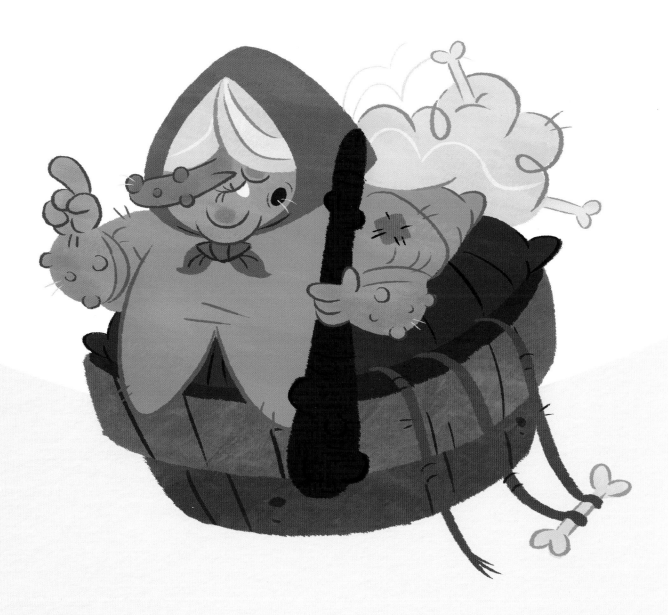

BABA YAGA IS BORN!

She's alive! This final look is a result of all the choices we have made throughout the design process. Her look remains true to tradition, the nesting doll aesthetic choice is still prominent, and the lighter tone and functional design mean she's ready to be animated! Throughout the journey to our final image, we've discussed many different options and paths to take when redesigning a classic character. The choices we made have led to this version, but think how many more iterations it would be possible to create! Have faith in the design process and you will always get to where you're trying to go when creating your own characters.

LOST IN SPACE!

RAÚL TREVIÑO

A fun way to spark your imagination is to design a character based on a random collection of words, in this case: "astronaut," "small," and "confusion." Straight away I had an idea come to mind, but this exercise isn't about expecting a result I can control, it's about letting ideas flow and going through the process until it starts making sense. Let's get started!

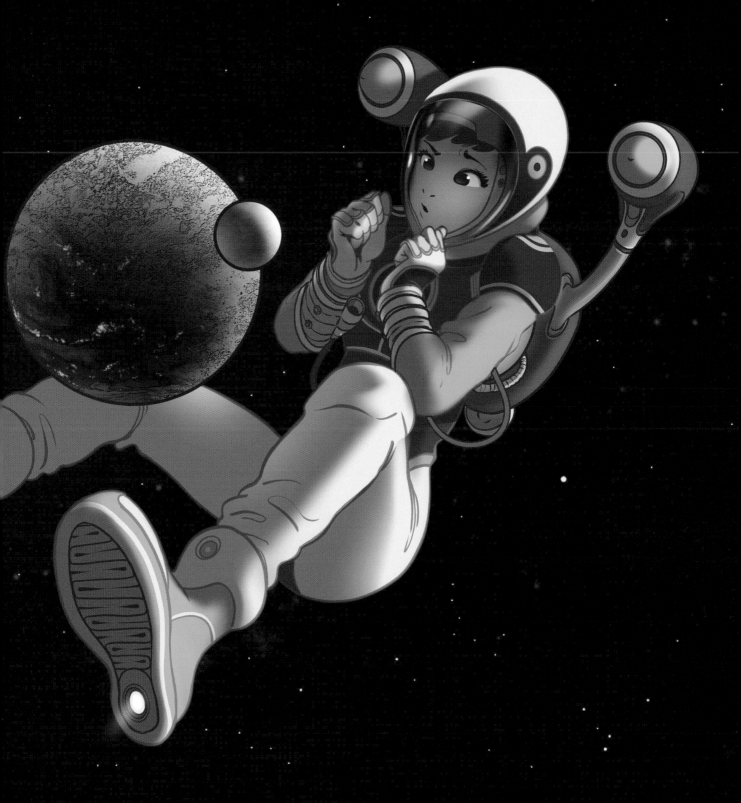

SILHOUETTE EXPLORATIONS

You've no doubt heard about warming up with silhouette drawings before – it's a well-known technique in the industry for a reason. Not only is it a great way to quickly explore different designs, it's also a super fun exercise!

LET YOUR IDEAS FLOW

At the start of the process I try not to focus too much on the details and let my ideas flow. I avoid putting up any obstacles or following any particular rules and just try to work with whatever is on my mind. If I feel like starting with colors, sketching, or even creating a character's prop, then I go with it! As I go through the process, I do have a common series of steps I follow, but these are guidelines I'm prepared to bend or break.

To control my insecurities when coming up with new ideas, I try to think of drawing in the same way I think of writing: doubts don't form in my head when writing something on paper – I feel free to experiment without worry. It should be the same with drawing.

I let my mind wander and the first idea I'm happy with is an astronaut confused at seeing a small planet in front of her.

SPACE IS THE PLACE

Usually, I start drawing my character's anatomy before working on their outfits. Practicing drawing human figures is something I do regularly. This helps me understand the proportions of the character before dressing them up, and I also gain a better grasp on who I'm trying to create. With my figure complete, I can start having fun imagining how they will look. I consider a floating pose for my astronaut — after all, she will be in outer space!

> "ASK YOURSELF QUESTIONS ABOUT YOUR CHARACTER AND YOU WILL ALWAYS FIND MORE INTERESTING IDEAS TO EXPLORE"

GETTING TO KNOW YOU

So, who is my character? I don't have to write out a full biography, but it can be helpful to consider some adjectives to describe them. I imagine my astronaut as a curious, distracted, and clueless teenager. Maybe she's exploring the universe in search of another kind of life form? Or maybe she is looking for a particular planet, only to discover it wasn't at all what she was expecting? The planet is so small she isn't able to land and explore – and in fact, she worries that being near it might cause climate change or other natural disasters! Ask yourself questions like these about your character and you'll always find more interesting ideas to explore.

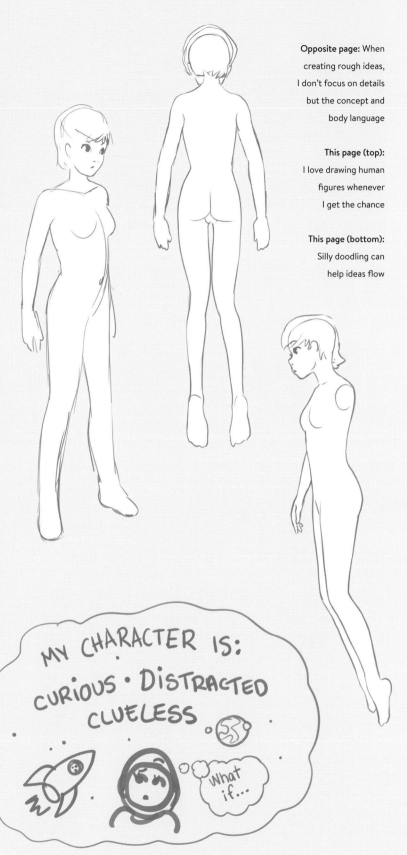

Opposite page: When creating rough ideas, I don't focus on details but the concept and body language

This page (top): I love drawing human figures whenever I get the chance

This page (bottom): Silly doodling can help ideas flow

MY CHARACTER IS: CURIOUS · DISTRACTED CLUELESS

What if...

RESEARCH IGNITES CREATIVITY

I decide to research spacesuits in more depth, and I find some exciting ideas on the NASA website. One of the things I like most about creating characters is drawing detail and having fun with specific functional aspects of a design – a spacesuit is ideal for this kind of work! I really want to understand the main features of a design, in this case the tools and accessories an astronaut would need, and find a way to show them clearly to the audience. Also, as an added bonus, more detail will make the design look more fun!

ACCESSORIZE THE DESIGN

Let's focus on the design of the jetpack. I'm creating a fictional character, so it's fine to stretch the fundamental aspects of the design beyond the realistic examples I find during my research. NASA's jetpack design is a rather boring big white box – I make my design lighter and more versatile, focusing on the aesthetic as well as the practicality of the device. It's important to always create designs that are believable, even if they are not entirely realistic. My next design quandary is: how can my astronaut manoeuvre gracefully and stop quickly when she approaches the tiny planet? I add mini thrusters to her hands and feet to give the impression she can react quickly. Details like this can drive the story in a particular direction and make the overall design more cohesive.

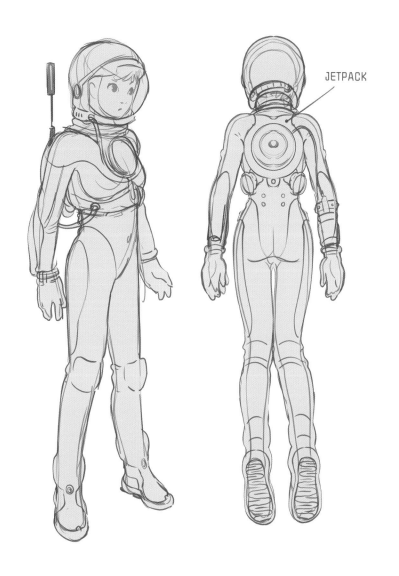

JETPACK

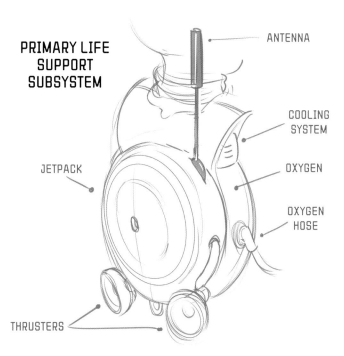

PRIMARY LIFE
SUPPORT
SUBSYSTEM

ANTENNA

COOLING
SYSTEM

OXYGEN

JETPACK

OXYGEN
HOSE

THRUSTERS

LATER I DECIDE TO ADD
BIGGER THRUSTERS

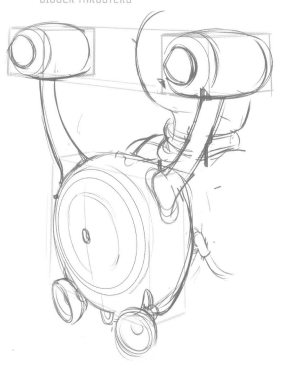

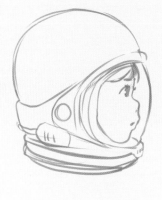
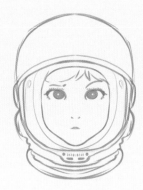
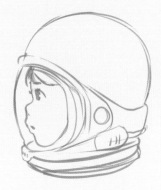

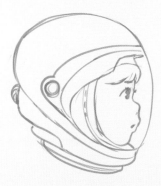
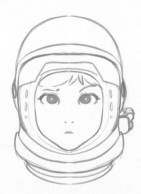
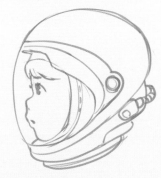

Opposite page (top): My astronaut needs a way to explore space... let's add a jetpack!

Opposite page (bottom): Focusing on specific characteristics can create interesting story beats

This page: Make sure the helmet looks good from front and side views

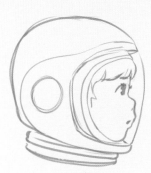
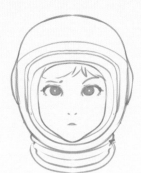

UNDERSTANDING DIMENSIONS

Working on the shape of the helmet is very important to the overall design because it's obscuring a large part of the character's head, where much of the character's personality would usually be defined. Understanding the dimensions of the helmet is crucial, and so I explore different angles before drawing the final design. Drawing a front view and a side view will give you a clear enough idea of the helmet's design, but you can go further if you need to. Try a top view, a three-quarter view, and so on. A little extra work now can save headaches later on – you don't want to redraw your character in a new pose and find that the design doesn't work from a new angle!

WE HAVE LIFT-OFF!

At this stage, I start to work toward a final design. I'm trying to apply what I've learned from my research while also incorporating new details. The front and profile view of the helmet will help you to work on the complete three-quarter view, an angle that's important to draw to understand how the character works in tridimensional space. If possible, try and find a pose that lets you show every part of your character's body – I do this by raising the astronaut's right hand to show her gloves in more detail.

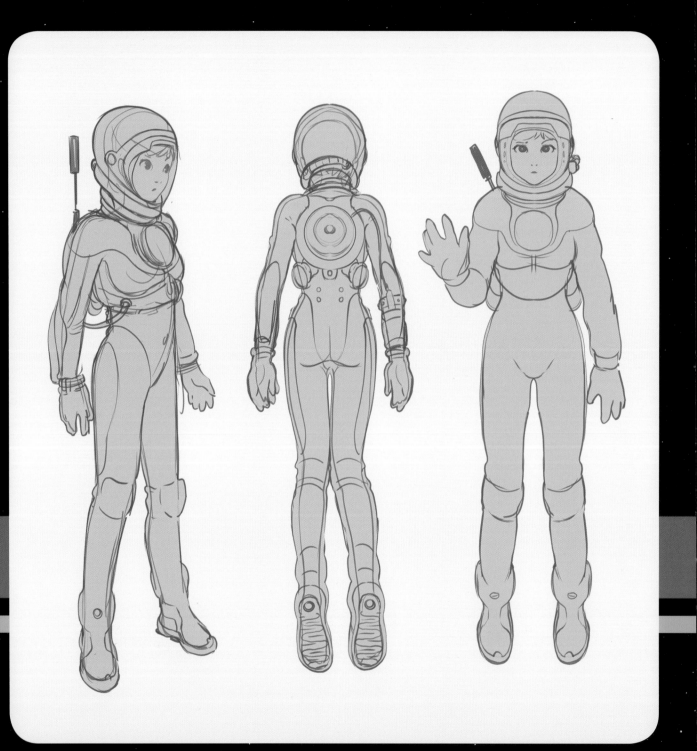

POSITIVES FROM NEGATIVES

Next, I want to make sure the design of the spacesuit is pleasing to the eye. This exercise helps you understand how you are going to ink and color the final piece. You don't have to spend too much time on the details – this is a quick study, the fundamental way to start working on contrasts. Think of this stage as a break from the main process of creating your character, which can help you understand where things are heading. It makes you think about small design details and maybe even come up with additions you haven't considered yet.

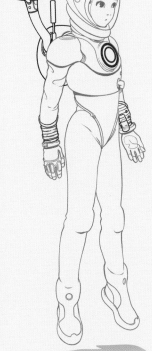

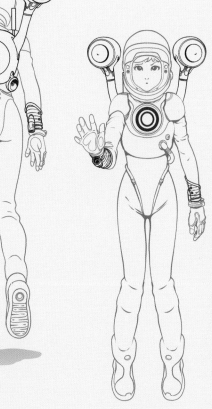

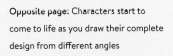

Opposite page: Characters start to come to life as you draw their complete design from different angles

This page (top): Adding contrast detail before coloring

This page (bottom): Think of defining the drawing as zooming in on details to make sure they make sense

> "I LOVE THE INKING PHASE BECAUSE IT'S WHEN I CAN START ADDING DEFINITION TO MY DESIGNS"

DEFINING THE DESIGN

I love the inking phase because it's when I can start adding definition to my designs, seeing details I didn't previously consider, and even sparking new ideas on the way! At this point, I start to see whether my design is really making sense and if I'm expressing what I want. This is almost the last chance to revisit the core design and be sure it's heading in the right direction before the final design.

"I BREAK DOWN THE COLORING PROCESS INTO COLOR, DETAILS, AND THEN LIGHT AND SHADING"

COLOR OUT OF SPACE

Sometimes a color palette will come to me fully formed in my mind, and sometimes I'll find them on sites such as Coolors or Color Hunt. These online resources can be a good place to start if I'm struggling to find a palette that works. I break down the coloring process into color, details, and then light and shading. First, I want to make sure my color palette is pleasant to look at, the design is clear, and the details of the character are being emphasized. I want to avoid having the viewer's gaze being drawn to one single point of the design. Once I've settled on the colors, I add light and shading – the key decision is to choose a light source that gives the character sufficient depth and tridimensionality.

A SEPARATE LAYER FOR LIGHT AND SHADING

I work on the light and shading on a separate layer so as not to worry about effecting the colors. Fill the layer with black, or any other color, apply Highlight or Overlay mode, and start deleting with a brush to spread light. This technique also allows me to make color variations without worrying about rendering again.

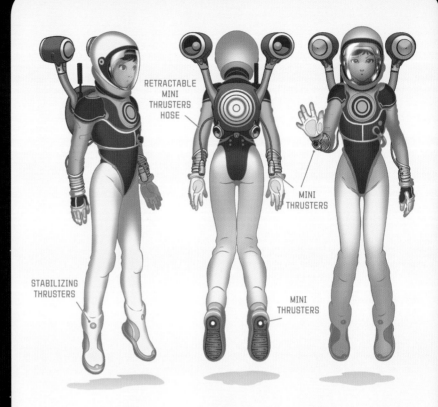

RETRACTABLE MINI THRUSTERS HOSE

MINI THRUSTERS

STABILIZING THRUSTERS

MINI THRUSTERS

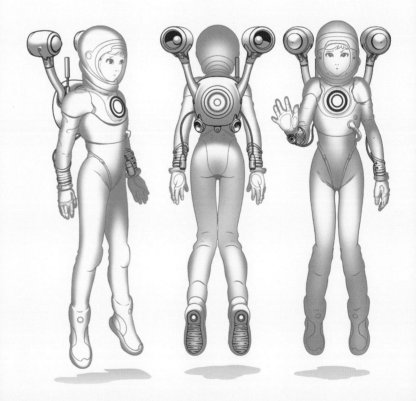

EXPERIMENTING WITH COLORS

Creating two or three color variations is a great way to see if your initial choices are really working. I keep my color scheme simple and my selection small on this design. Still, sometimes I like to get a little crazy, mixing vivid colors, unexpected color holds, and mismatching different palettes. Don't forget to have fun and allow yourself to be surprised! If you try to control the outcome too much, the whole process can start to feel stressful and boring. Playing with color combinations is a great way to reinvigorate your own sense of excitement in your design.

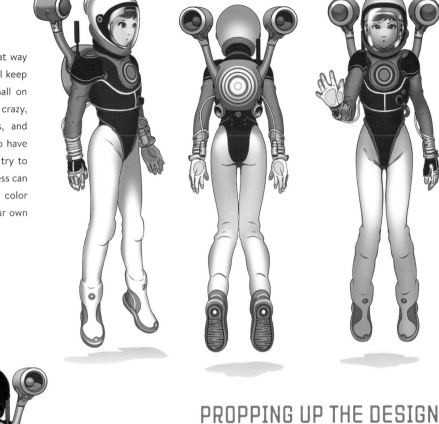

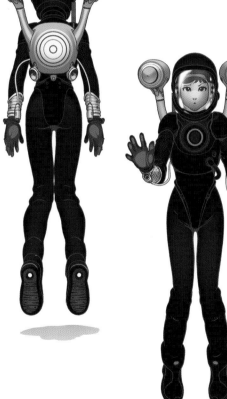

PROPPING UP THE DESIGN

You might be creating a character that will be used across different media, so even though the final illustration won't show a back view, understanding how the jetpack works and interacts with the astronaut is crucial. Exploring props not only makes the character's world more believable, it can also help with the overall design cohesion of the piece.

Opposite page: Light and shading don't necessarily have to respect reality

This page (top): Color variations will help to ensure you have the best color palette for your character

This page (bottom): Think of props as an extension of your character

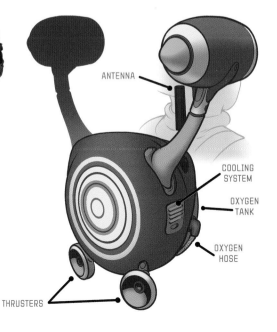

ANTENNA

COOLING SYSTEM

OXYGEN TANK

OXYGEN HOSE

THRUSTERS

READING BETWEEN
INVISIBLE LINES

Now, with the help of the character's model sheet, it's time to make our astronaut come to life! I try to place the planet she encounters inside an imaginary triangle that connects many elements of the piece together. There are many grid systems you can use for composition (such as the rule of thirds) and you can also play with lines by tracing them over your drawing to make sure it's what you want to express. Playing with foreshortening and overlap will give the illustration a sense of depth. Also, be mindful of your character's eyes – the direction they are looking can be an excellent way to guide your viewer's attention to an essential part of the illustration.

> "PLAYING WITH
> FORESHORTENING AND
> OVERLAP WILL GIVE
> THE ILLUSTRATION
> A SENSE OF DEPTH"

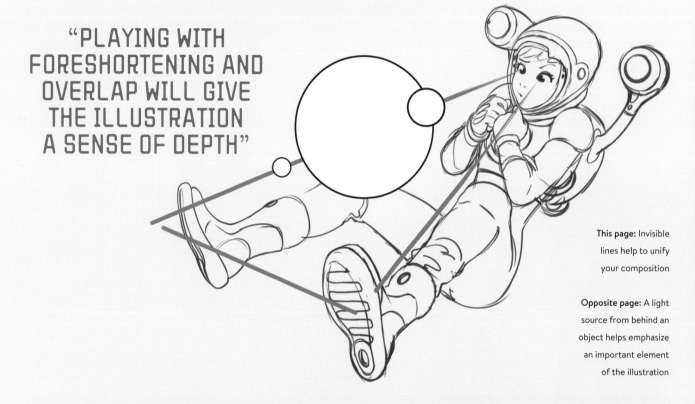

This page: Invisible lines help to unify your composition

Opposite page: A light source from behind an object helps emphasize an important element of the illustration

POSITIONING
IS EVERYTHING

Initially my character was floating upside down or horizontally, but I realise these poses might make it hard to read her confused expression. Also, when I finish rendering the final image, it bothers me that the astronaut's hands aren't clear once in color. I redraw her hands to more precisely show her reluctance to touch the planet.

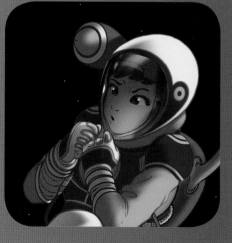

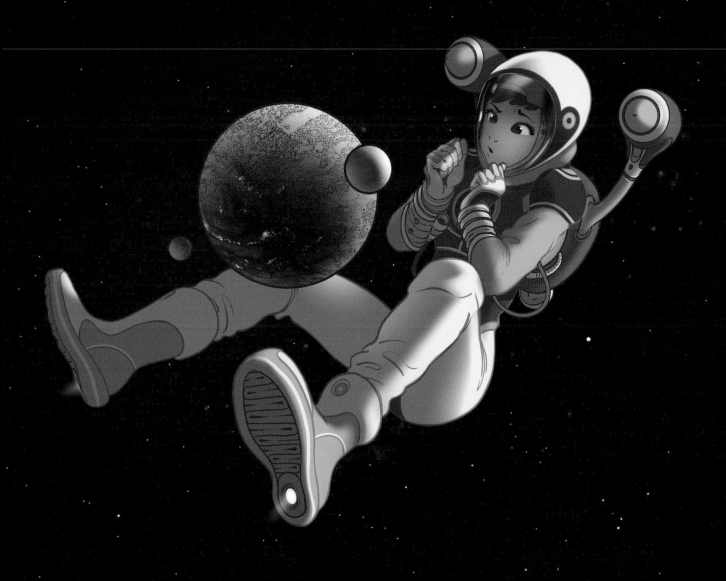

SMALL PLANET, BIG IDEAS

Light and shading are critical in every illustration. Using rim lights or lighting objects from behind are good ways to emphasize details in shadow. At the last minute, I have the idea to place one side of the planet in shade and create lights from cities on the surface – a detail that further enriches the narrative. The astronaut's full attention is on the planet, her surprised look telling the audience that this is an unusual situation! At the same time, there are many questions that remain unanswered: Is she a giant? Has the planet been shrunk? It's important to leave your audience with something to think about – make sure your picture is still on their mind long after they've finished looking at it!

Final image © Raúl Treviño

CONTRIBUTORS

AMELIA BOTHE

Sophomore at Maryland
Institute College of Art

botheamelia.wixsite.com/pixus

After graduation, Amelia hopes to jump into illustrating and publishing children's books, with a focus on creatures, both real and whimsical!

WOUTER BRUNEEL

Senior Artist at
Big Fish Games

instagram.com/wbruneel

Wouter started in 2D animation and working in the mobile games industry. He works as a character designer and production artist.

JULIA KÖRNER

Illustrator, Character Designer, and Visual Development Artist

dyru.de

Julia works as a freelance visual development artist for game studios, books and magazines, and does private commissions and personal projects.

ARCHINA LAEZZA

Illustrator

archisgoodies.bigcartel.com

Archina Laezza is an illustrator born and based in Naples, Italy. She is mainly a children's illustrator, but also designs stationery products.

CARLOS LUZZI

Character Designer and Animator

instagram.com/luzzicarlos

Carlos is an animation artist from Brazil who has worked as a character designer and animator on *Maya and the Three*, *Klaus*, and many more.

DOM "SCRUFFY" MURPHY

Character Designer

instagram.com/
scruffyshenanigans

Dom "Scruffy" Murphy is a character designer in the animation industry. He uses humor to soften the hard edges of life in his body of work and designs.

LAURA PAUSELLI

Freelance Visual
Development Artist

instagram.com/fulemy

Laura Pauselli is a Visual Development Artist based in Italy. She is currently attending the IDEA Academy and collaborating with Galactus Studio.

MEIKE SCHNEIDER

3D Artist, Illustrator,
and Character Designer

meikearts.com

Meike Schneider is a character designer, illustrator, and 3D artist based in Germany. She has worked in books, advertising, and animation.

RAÚL TREVIÑO

Comic author and
Character Designer

raultrevino.art

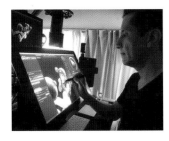

Raúl is a Mexican comic author living in Japan. He recently finished the comic *Magic Soda Pop*, and is developing *Second Skin*, a new graphic novel.

JEANNE WONG

Freelance Artist

Instagram.com/chwys_art

Jeanne is a freelance artist who lives in Singapore and loves drawing digitally, but also dabbles in watercolors, here and there.

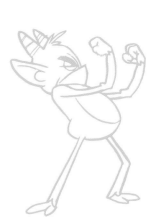

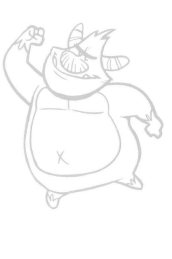

SPACE HELMETS
BY LORENZO ETHERINGTON

ANOTHER APPROACH: DRAWING IN **PROFILE**, YOUR DESIGN WILL **READ BETTER** IF DIVIDED INTO **THREE OR FOUR DISTINCT SECTIONS OF DIFFERING SIZES.**

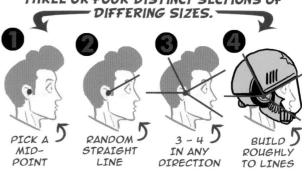

1 PICK A MID-POINT

2 RANDOM STRAIGHT LINE

3 3 - 4 IN ANY DIRECTION

4 BUILD ROUGHLY TO LINES

YOU CAN BREAK UP THE **HELMET MASS** BY BUILDING **IN SECTIONS** OVER THE **SKULL.**

1 **2** **3** **4**

MORE LINES DIVIDING UP FORM = MORE DEPTH OVERALL

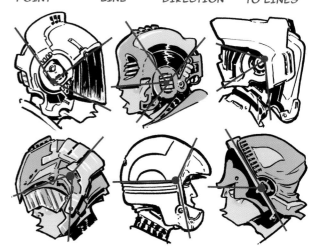

BUILD A DISTINCTIVE SILHOUETTE BY PICTURING AN **IMAGINARY LINE** JUST BELOW THE EYES, WITH **TOTALLY DIFFERENT ELEMENTS IN EACH HALF.**

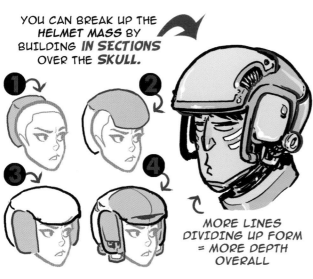

KEEP IN MIND **THE THREE F'S** OF COSTUME DESIGN - **FIT, FORM** AND **FUNCTION!**

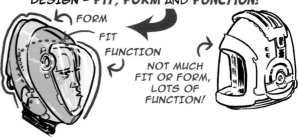

FORM
FIT
FUNCTION

NOT MUCH FIT OR FORM, LOTS OF FUNCTION!

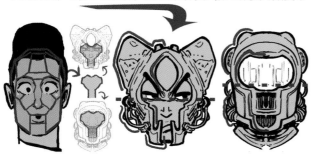